design

Sense

ROCKPORT

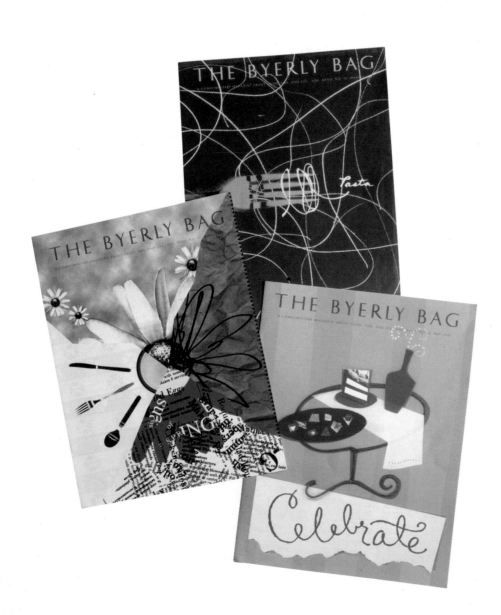

design Sense

graphic design on a limited budget

GLOUCESTER MASSACHUSETTS

ROCKPORT PUBLISHERS

Anistatia R Miller

& Jared M. Brown

First published in the United States of America by:
Rockport Publishers, Inc.
33 Commercial Street
Gloucester, Massachusetts 01930-5089
Telephone: (978) 282-9590
Facsimile: (978) 283-2742

Distributed to the book trade and art trade in the United States by:
North Light Books, an imprint of
F & W Publications
1507 Dana Avenue
Cincinnati, Ohio 45207
Telephone: (800) 289-0963

Other Distribution by:
Rockport Publishers, Inc.
Gloucester, Massachusetts 01930-5089

ISBN 1-56496-461-2

10 9 8 7 6 5 4 3 2 1

Designer: Amanda Kavanagh, ARK Design/NY

Projects on cover designed by: Design Center; Grafik Communications,
Ltd.; Scott Weaver Photodesign; Phil Fass; Halapple Design &
Communications, Inc.; Misha Design Studio; Sagmeister, Inc.; Stewart
Monderer Design, Inc.; University of Delaware Dept. of Art

Printed in Hong Kong

acknowledgments

We'd like to thank the entire staff at Rockport Publishers, Inc. for their support and encouragement on this project. A special note of thanks goes to our acquisitions editor Shawna Mullen for her keen perspective, our editor Alexandra Bahl for keeping us on track, and senior designer Kathy Feerick for quality-controlling the mountains of submitted art. We also want to thank our agent Lew Grimes for his continued support.

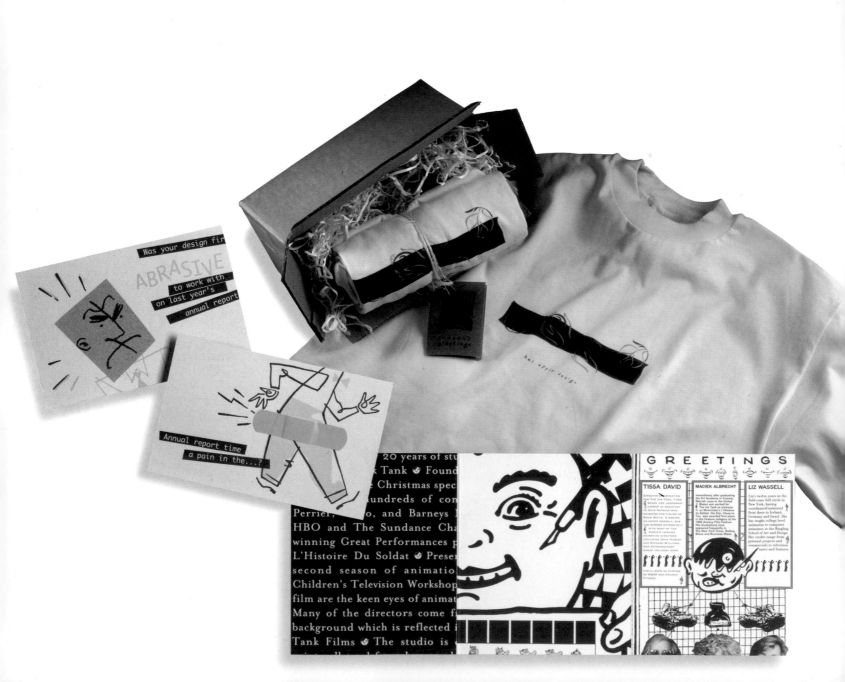

contents

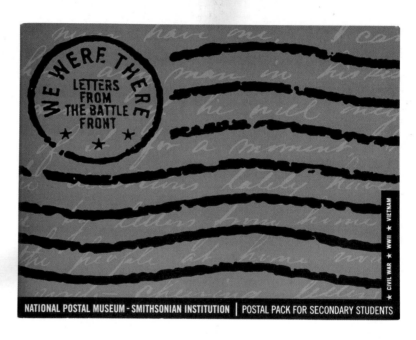

introduction

There are three elements to juggle in every design job: time, quality, and money. If you press one, it will affect the other two. Rush a job and your costs will increase while the quality of the job declines. Take extra time and the quality will increase, but so will the production costs. Decrease the budget and your clients will love you forever *if* you can keep quality and time from being adversely affected.

Every professional graphic designer has encountered an enthusiastic client whose hopes and dreams exceed the reality of the project's budget. On the flip side, every potential client needs to know that the term "low budget" doesn't mean a brochure, poster, or Website has to look cheap just because the designer was willing to accept, and was even inspired by, the project's economics. Intuition, ingenuity, and inventiveness on the part of the designer, in both the design and production phases, coupled with openness and objectivity on the part of the client, can yield some amazing results that don't squander precious time, quality, or money.

The success of *Graphic Design (on a Limited Budget): Cutting Costs Creatively for the Client* (Rockport Publishers, 1995) clearly demonstrated that it is possible to design a promotional or marketing piece economically by using fresh ideas, daring production techniques, and new presentation solutions. However, the design world changes rapidly. In the past three years, technology has introduced cost-effective ways to produce and distribute multimedia projects on floppy disks and CD-ROMs. The World Wide Web has created a phenomenal means for delivering information in full color (even with animation) throughout the world for less in materials cost than the price of a conventional black-and-white ad in a small-town newspaper.

And there's been a design and production backlash in recent years: a rediscovery of less mass-produced projects that appear more organic dominated the 1980s and early 1990s. This alternate direction can partially be blamed on the world's sudden immersion into computers, the Web, color inkjet printers, digital printing systems, DVD, and numerous other electronic communications devices. With software that can produce slick, professional, and rather bland, designs now readily available, designers must search for aesthetics from hand-tinted photography, hand-cut color separations, hand-assembled booklets, or hand-bound brochures. And once again, they must be willing to spend a few hours honing their manual skills if they want their work to stand out.

As you wander through the pages of this volume, you'll soon discover for yourself the truth to the adage that 'money isn't everything.' But you'll also see that there are no limitations on the variety and range of design solutions that can be achieved on a limited budget.

announcements & invitations

Invitations to or announcements of special events can be great vehicles for attracting an audience. However, small print runs of less than 500 pieces and the need to create an eye-popping first impression often send production expenses soaring. Besides waiving the design fee, many designers are scouring specialty paper shops for off-the-shelf

card and envelope stock. They are contracting with quick-print houses to run jobs in two PMS colors or with service bureaus to print four-color on digital printers. And they're producing striking solutions. Some designers are even devising graphic treatments that can be reproduced in-house on black-and-white or color photocopiers and laser printers.

There also seems to be a resurgence in designing standard-sized (4" x 6") full-color postcards and having them inexpensively printed by a specialty printing house, which gangs up the job with other projects. DIY (do it yourself) has also made a comeback, with both studios and clients getting into the act of assembling and binding entire packages.

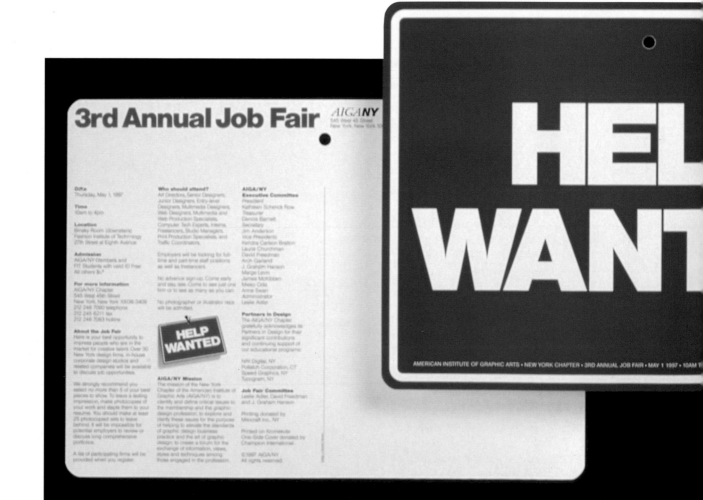

Frank Owens and Margaret Burke are pleased to announce that their daughter Audrey has a brand new baby brother

Francis Sylvester Owens IV
Two Twenty One pm
Seven Pounds Four Ounces
February Twenty Fifth
Nineteen Hundred Ninety Six
Mount Sinai New York City

OWENS & BURKE BIRTH ANNOUNCEMENT

DESIGN FIRM: J. Graham Hanson Design
LOCATION: New York, NY
CLIENT: Frank Owens & Margaret Burke
LOCATION: New York, NY
DESIGNER: J. Graham Hanson
DISTRIBUTION: 100 pcs., Regional

Waiving the design fee on this project was only the beginning in a list of economic measures. The designer reduced the cost further by using off-the-shelf paper stock and a text-oriented concept that distracts from the economical single-color offset printing. Using shapes formed out of the actual text, the visual has impact without relying on any additional graphic elements.

HELP WANTED

DESIGN FIRM: J. Graham Hanson Design
LOCATION: New York, NY
CLIENT: American Express
LOCATION: New York, NY
DESIGNER: J. Graham Hanson
DISTRIBUTION: 3,500 pcs., Regional

Although the designer waived the fee on this project, the true cost savings took place in its production. This sign was created so the hole could simply be drilled and the rounded corners ground down, which saved the cost of producing a special die to replicate the same effect.

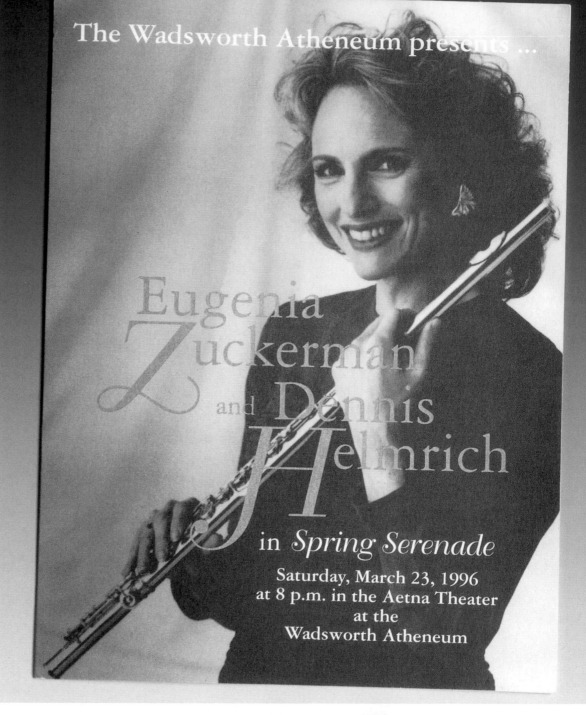

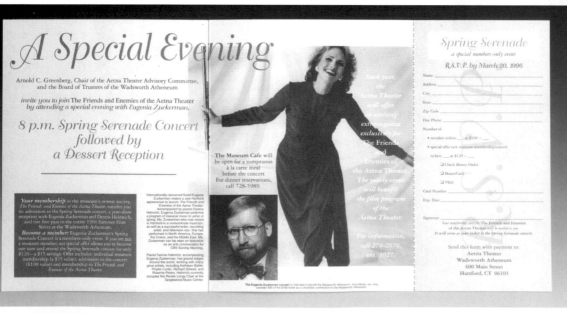

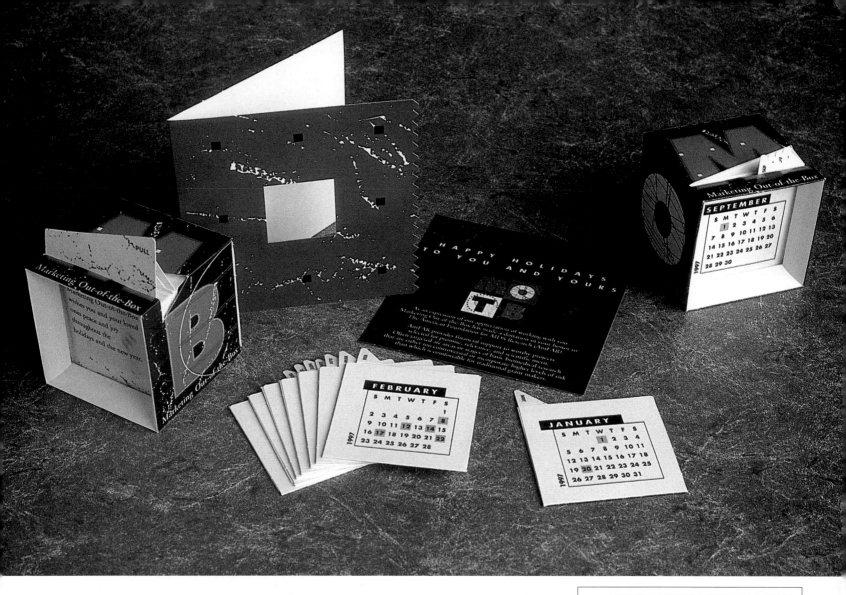

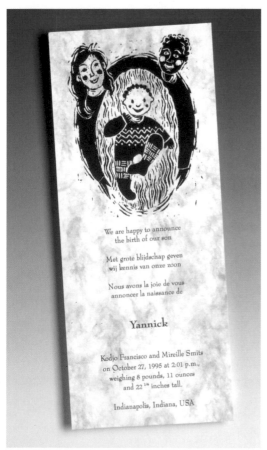

DESIGN FIRM: Jim Lange Design
LOCATION: Chicago, IL
CLIENT: Marketing Out-of-the-Box
LOCATION: Chicago, IL
ART DIRECTOR: Allison Hafti
DESIGNER: Jim Lange
ILLUSTRATOR: Jim Lange
DISTRIBUTION: 1,000 pcs., Local

To greatly reduce labor costs, the employees and owners of the client company assembled the eighteen pieces that make up this calendar and holiday announcement.

YANNICK

DESIGN FIRM: Mireille Smits Design
LOCATION: Indianapolis, IN
CLIENT: Kodjo Francisco and Mireille Smits
LOCATION: Indianapolis, IN
DESIGNER: Mireille Smits
ILLUSTRATOR: Mireille Smits
DISTRIBUTION: 200 pcs., International

This single-color birth announcement was printed on a photocopier using off-the-shelf specialty paper. The cards were printed two-up on an 8.5" x 11" sheet of paper to further economize on production.

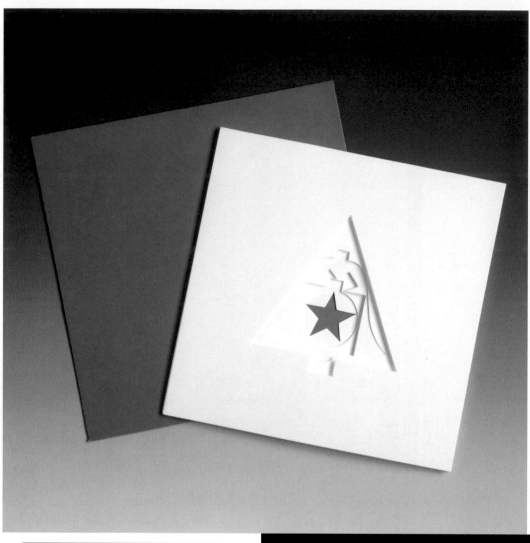

CHRISTMAS CARD

DESIGN FIRM: Sagmeister, Inc.
LOCATION: New York, NY
CLIENT: Museum of Modern Art
LOCATION: New York, NY
ART DIRECTOR: Stefan Sagmeister
DESIGNER: Susanne Poelleritzer
ILLUSTRATOR: Susanne Poelleritzer
DISTRIBUTION: 10,000 pcs., National

Unlike other holiday cards that rely on four-color imagery, foil, and other complex elements, this Christmas greeting employs one-color printing and die cuts to create an effective presentation.

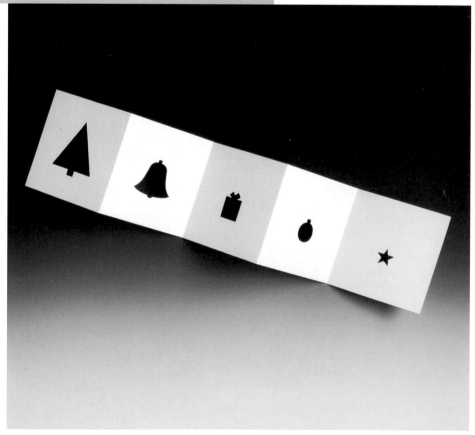

LAW OFFICES OF CHARLES WILLIAMS

DESIGN FIRM: Atlantic Design Works
LOCATION: West Hartford, CT
CLIENT: Charles Williams, Esq.
LOCATION: West Hartford, CT
ART DIRECTOR: Stacy W. Murray
DESIGNER: Stacy W. Murray
PHOTOGRAPHER: Timothy Belker
DISTRIBUTION: 2,000 pcs., National

The client wanted a professional announcement that would be more elegant than a conventional engraved card, but a four-color solution was out of the question. The design studio hired a photographer and used a halftone of the finished portrait. An on-hand square envelope inspired the final size and shape of the piece, which was printed on an 80-pound classic linen cover stock, using two PMS colors and screen variations.

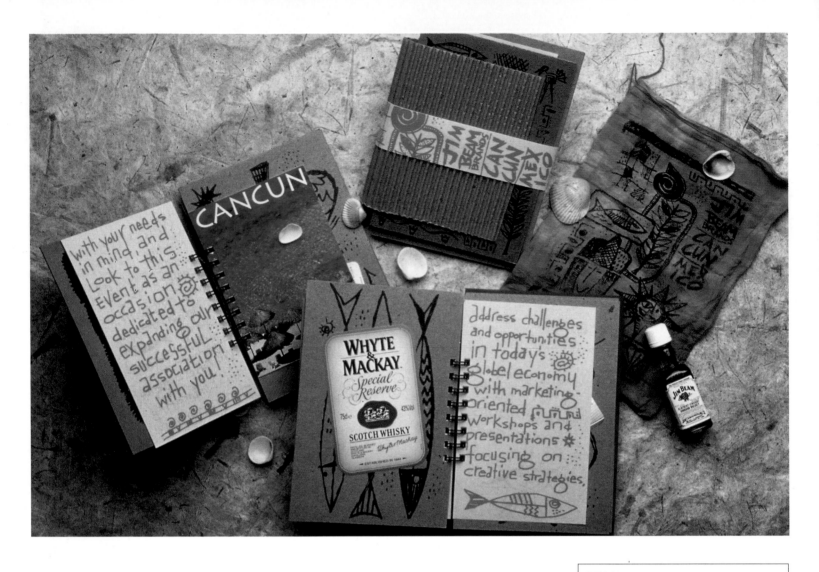

CANCUN

DESIGN FIRM: Sayles Graphic Design
LOCATION: Des Moines, IA
CLIENT: Jim Beam Brands
LOCATION: Deerfield, IL
ART DIRECTOR: John Sayles
DESIGNER: John Sayles
ILLUSTRATOR: John Sayles
DISTRIBUTION: 75 pcs., International

Short-run projects that require high impact at a reasonable price present ideal opportunities to apply hand-constructed design solutions. This invitation to a meeting employs a number of inexpensive elements. The client supplied the product labels and samples. The four-color postcards were gang-printed by a postcard printer. And the in-stock muslin bags were hand-dyed and silk-screened in the Sayles's basement. All the finished pieces were assembled by hand.

UNIVERSITY OF DELAWARE
DEPARTMENT OF ART POSTCARDS

DESIGN FIRM: University of Delaware Dept. of Art
LOCATION: Newark, DE
CLIENT: University of Delaware Dept. of Art
LOCATION: Newark, DE
ART DIRECTORS: Martha Carothers, Raymond Nichols
DESIGNERS: Senior-level students
PHOTOGRAPHERS: Senior-level students
DISTRIBUTION: 500 pcs., Regional

The design team followed the restrictions specified by the postcard printer for a limited-edition run. Consequently, to reduce the costs, the copy for the front image had to be incorporated into the photograph so that a 35 mm side was the only element submitted. One-color text-only for the back further enhanced the mailing's economics.

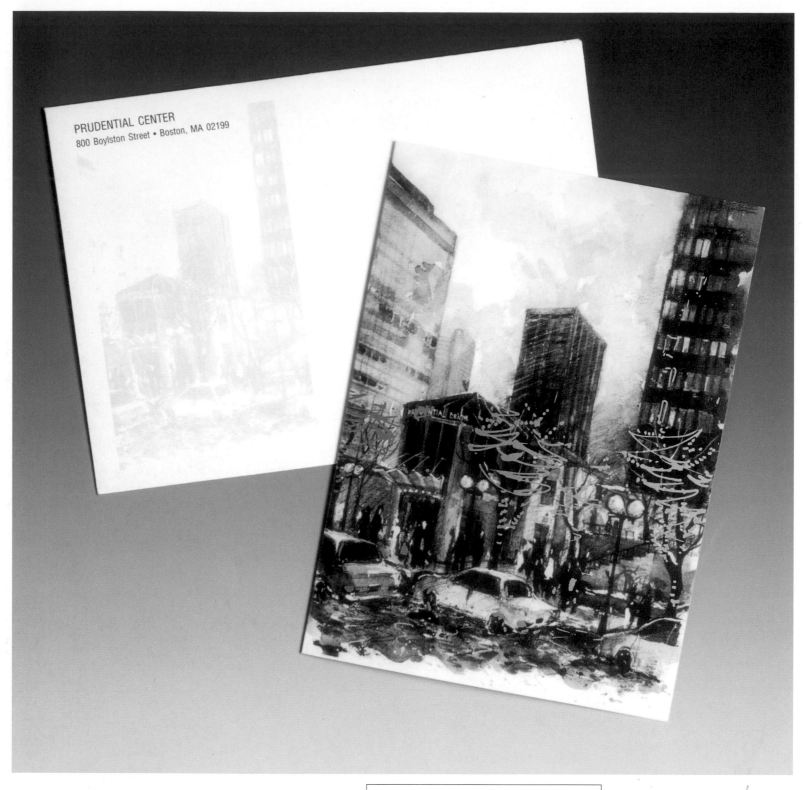

PRUDENTIAL CENTER
800 Boylston Street • Boston, MA 02199

PRUDENTIAL CENTER CHRISTMAS CARD

DESIGN FIRM: Misha Design Studio
LOCATION: Boston, MA
CLIENT: Prudential Center
LOCATION: Boston, MA
ART DIRECTOR: Michael Lenn
DESIGNER: Michael Lenn
ILLUSTRATOR: Michael Lenn
DISTRIBUTION: 1,000 pcs., Regional

The client wanted a view of its building to appear in its holiday greeting and a final piece that didn't use the traditional red and green color palette. So the designer developed a two-color solution incorporating a black-and-white rendering highlighted with gold stamping, which provides additional depth and texture to the finished piece.

hello emily and scott. this is glenn calling.
i'm leaving this message to update you on the
correct information for the erik, i mean GREGORY
birth announcement. the time of birth is

8:44am

...not 9:00 am. the rest of the information
is correct. the date is september 12, 1992.
the weight is 7lbs 1.9 ounces,
the length 19½ inches and the name—
GREGORY JOSEPH SANTORO.
i hope this adds to your artistic
endeavor, and thanks from
marianne, erik, GREGORY and me.
talk to you later.

m, e, G+g, 36 noel lane forestville connecticut 06010

design: emily + scott santoro

8:44 AM

DESIGN FIRM: Worksight
LOCATION: New York, NY
CLIENT: The Glenn Santoro Family
LOCATION: Bristol, CT
DESIGNER: Scott Santoro
PHOTOGRAPHER: Scott Santoro
DISTRIBUTION: 200 pcs., Local

*The inspiration for this announcement came from
a message left on the family's answering machine
regarding the information that needed to be
included in the project. The announcement was
printed two-up on one side of an 8.5" x 11"
parchment card stock in one PMS color.*

There can be no economy
where there is no efficiency.

—Beaconsfield

DESIGN FIRM: Cappelletto Design Group
LOCATION: Vancouver, BC, Canada
CLIENT: Gillian and Todd Heintz
LOCATION: Vancouver, BC, Canada
ART DIRECTOR: Ivana Cappelletto
DESIGNER: Antonia Banyard, Ivana Cappelletto
DISTRIBUTION: 178 pcs., Local

Design and production fees were waived to create this project, which was printed on a digital press. The designer's very close friends decided to wed while floating on a barge in New York harbor. The waiter supplied the tinfoil for the engagement ring and the date was set. The couple wanted their friends and family to participate in a big party with a casual barbecue after the official private ceremony and a magical honeymoon tour. Their story was presented in clip art and personal archival photography along with directions and a map to the party. The final piece was mailed out in earth-tone envelopes.

Our lives together began in

November 199?

as unsuspecting guests at a mutua

dinner party. Little did we know....

After three years of charting time together,

I led Gillian to New Yo

- it would be a difficult sell -

a barge in Brooklyn and a tinfoil ring....

Caught off guard,

nced shock (a tin foil ring?)

helming sense of happiness.

my breath, I enthusiastically

accepted Todd's proposal. On

with no ma

by the

of our famili

into

But Beautiful

Who can say what love is?
Does it start in the mind or the heart?
When I hear discussions on what love is,
Everybody speaks a different part.

Love is funny or it's sad
Or it's quiet or it's mad;
It's a good thing or it's bad,
But beautiful!

Beautiful to take a chance
And if you fall, you fall,
And I'm thinking
I wouldn't mind at all.

Love is tearful or it's gay;
It's a problem or it's play;
It's a heartache either way.
But Beautiful!

And I'm thinking
If you were mine I'd never let you go,
And that would be
But Beautiful I know.

Lyric by Johnny Burke

Gillian Ruth
H U R T I G

'd Gregory
I N T Z

d's

Destined to experience the joys of being

husband and wife, lovers and companions, we will set off

for the wonders of Europe. The bistros and wine bars

of the City of Light, *Paris,* will be our first stop.

From there we will engage Dionysus,

the Greek God of *Wine,*

and Aphrodite, the Goddess of *Love,*

as we frolic in the *Mediterranean.*

After three weeks of travel we will return to share our

excitement and experiences with friends and family. We

invite you to join us for a casual evening of celebration on

August 16, 1997 at 6:00pm

at the home of Les and Hazel Cosman.

Dinner and drinks will be served.

Please RSVP by phone to Todd and Gillian by

May 31, 1997, 604-737-4838.

y 19,

and, but guided

e and support

will embark on a new journey

Marriage

small, intimate family wedding.

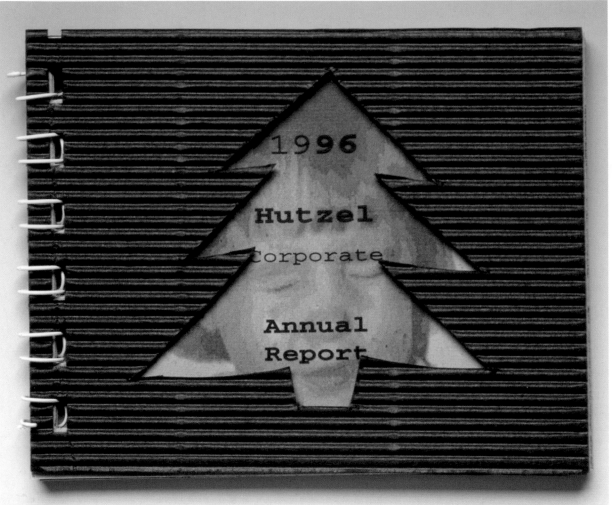

1996 HUTZEL CHRISTMAS CARD

DESIGN FIRM: Barry Hutzel
LOCATION: Holland, MI
CLIENT: Barry Hutzel
LOCATION: Holland, MI
ART DIRECTOR: Barry Hutzel
DESIGNER: Barry Hutzel
PHOTOGRAPHERS: Barry Hutzel,
Sharon Hutzel
DISTRIBUTION: 75 pcs., National

The 1996 Hutzel Christmas card was a hand-made effort that the couple created on a laser printer and ran on donated tan paper stock. The front and back covers were created using a black corrugated board leftover from a previous project. The Christmas tree shape in the front cover was hand cut. The final binding was executed on borrowed equipment.

What Paige is thankful for

I am most thankful for God, fun with my family, friends
and myself
• I am thankful for the special friendship I have with my
neighbor Mary
• My Cinderella and ballerina costumes
• I Love pens, pencils, markers and crayons
• All the different papers Daddy brings home to use my pens,
pencils, markers and crayons on

What Eden is thankful for

• I most tanful for my happy buthday to you
• I tanful for TV and videos and Toy Sory and Fuzz and
Woodey and Aladin and Beutey&Beas and the Lion King
• I really happy for Diapers
• Goofy Goofy Goofy
• My blankey
• My "Baa" at the end of the day

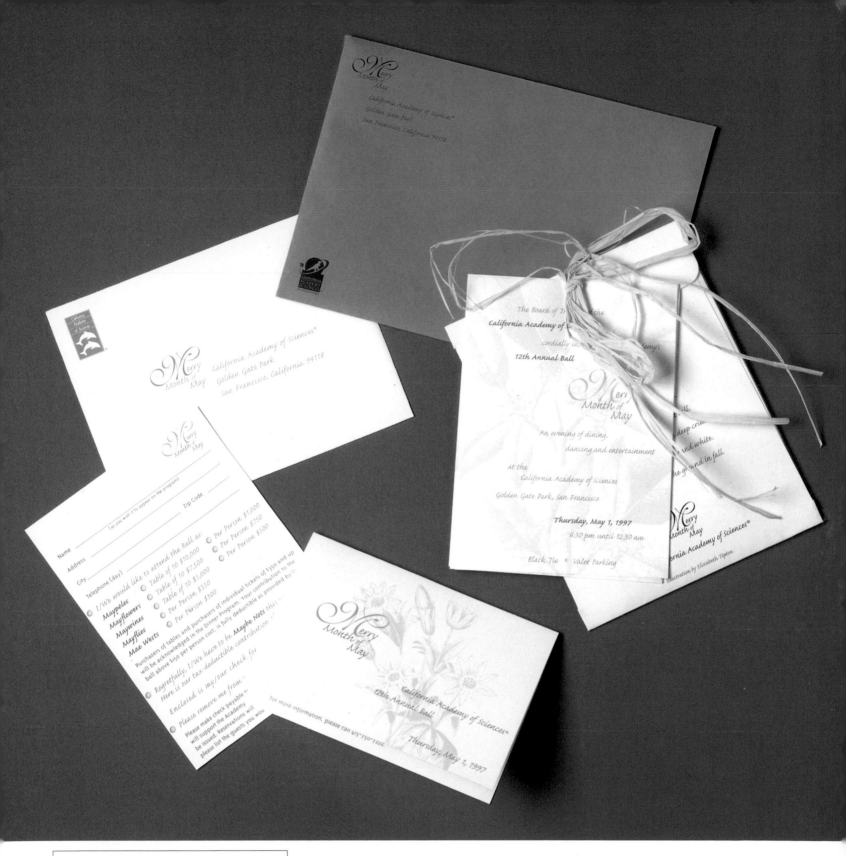

MERRY MONTH OF MAY INVITATION

DESIGN FIRM: Kiku Obata & Company
LOCATION: St. Louis, MO
CLIENT: California Academy of Sciences
LOCATION: San Francisco, CA
ART DIRECTOR: Amy Knopf
DESIGNER: Amy Knopf
ILLUSTRATOR: Elizabeth Tipton
DISTRIBUTION: 3,000 pcs., Local

The illustrator donated the lovely floral watercolor used on the packet of hollyhock seeds sent to each invitee to this annual black-tie charity ball. The four-card invitation itself was printed in two PMS colors and attached to the seed packet with a piece of natural raffia. Background illustrations used on the cards were found in a clip-art book. Two reply cards were also printed in the same PMS colors so all of the materials could be printed on the same sheet to reduce costs. The reply envelope and the entire package fit neatly into a one-color mailer printed on pastel-colored stock.

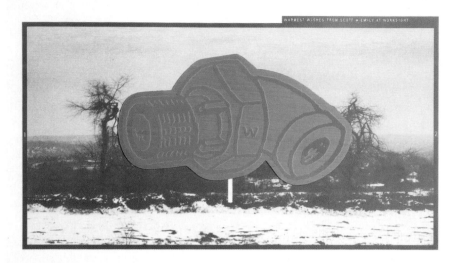

WARMEST WISHES FROM SCOTT + EMILY AT WORKSIGHT

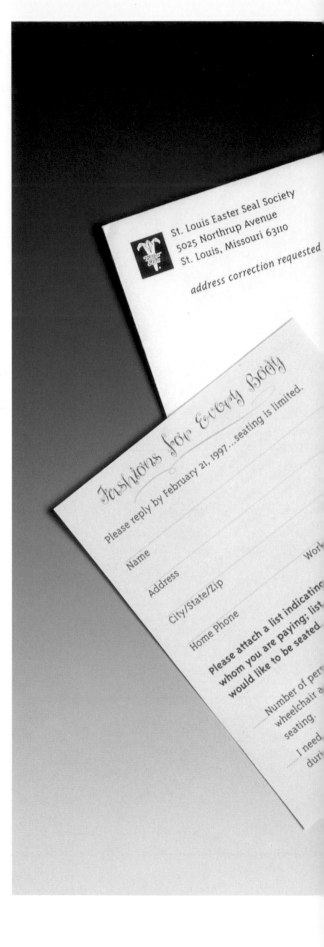

WARMEST WISHES MAGNET CARD

DESIGN FIRM: Worksight
LOCATION: New York, NY
CLIENT: Worksight
LOCATION: New York, NY
DESIGNER: Scott Santoro
PHOTOGRAPHER: Scott Santoro
DISTRIBUTION: 250 pcs., National

The photograph on this one-color card was shot by the designer himself and economically printed on a glossy coated stock. Each card was glued to a metal sheet and a piece of cardboard. The one-color metal-based refrigerator magnet was then placed on top of each card and shipped as the studio's holiday promotion.

FASHIONS FOR EVERYBODY

DESIGN FIRM: Kiku Obata & Company
LOCATION: St. Louis, MO
CLIENT: Easter Seals Society
LOCATION: St. Louis, MO
ART DIRECTOR: Amy Knopf
DESIGNER: Amy Knopf
ILLUSTRATOR: Amy Knopf
DISTRIBUTION: 2,000 pcs., Regional

This 12-page flip book announcement was printed in two PMS colors on pastel paper stock donated by a local manufacturer. The flip pages themselves were hand cut by the studio after the books were bound. The small format (4.25" x 5.5") fit into a standard invitation envelope along with a reply card and a smaller return envelope, economizing even further on the project's overall costs.

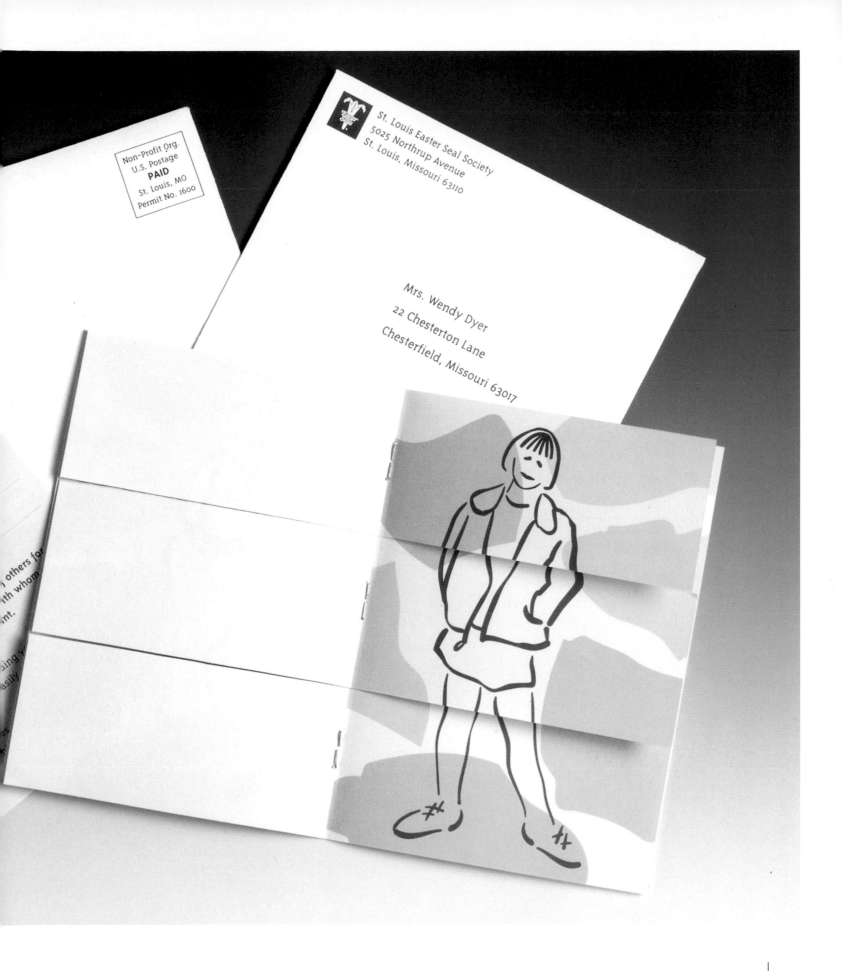

Non-Profit Org.
U.S. Postage
PAID
St. Louis, MO
Permit No. 1600

St. Louis Easter Seal Society
5025 Northrup Avenue
St. Louis, Missouri 63110

Mrs. Wendy Dyer
22 Chesterton Lane
Chesterfield, Missouri 63017

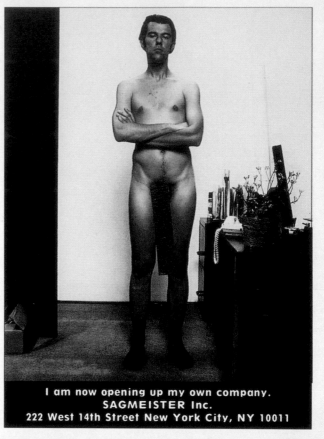

Having worked for the Schauspielhaus in Vienna, TBWA in London, Leo Burnett in Hong Kong and M&Co. in New York,

I am now opening up my own company.
SAGMEISTER Inc.
222 West 14th Street New York City, NY 10011

OPENING ANNOUNCEMENT

DESIGN FIRM: Sagmeister, Inc.
LOCATION: New York, NY
CLIENT: Sagmeister, Inc.
LOCATION: New York, NY
ART DIRECTOR: Stefan Sagmeister
DESIGNER: Stefan Sagmeister
ILLUSTRATOR: Eric Zim
PHOTOGRAPHER: Tom Schierlitz
DISTRIBUTION: 1,000 pcs., International

This studio announcement takes advantage of the standard postcard's three basic economies. A postcard printer produced a short run of standard 4" x 6" cards for $350. The tastefully positioned black tapes were applied by hand at the studio. And the 12¢ per-unit saved by mailing postcards rather than first-class envelopes added to the overall savings.

The perpetual obstacle to human advancement is custom.

—John Stuart Mill

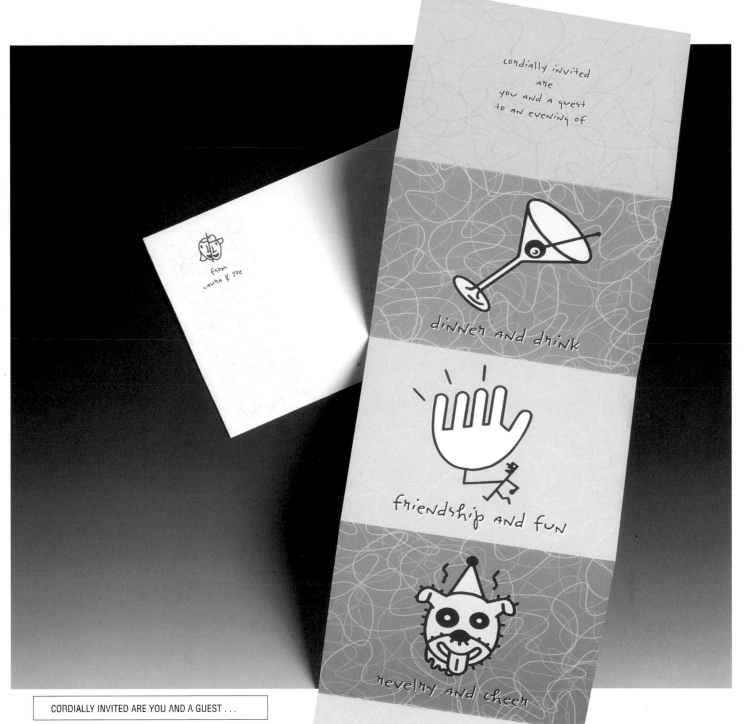

cordially invited
are
you and a guest
to an evening of

dinner and drink

friendship and fun

revelry and cheer

at
LAURA AND JOE'S
ON
MAY 17
AT
7:00pm

r.s.v.p. 617-374-9600 extension 337

from
LAURA & JOE

CORDIALLY INVITED ARE YOU AND A GUEST . . .

DESIGN FIRM: Stewart Monderer Design, Inc.
LOCATION: Boston, MA
CLIENT: Pegasystems, Inc.
LOCATION: Boston, MA
ART DIRECTOR: Stewart Monderer
DESIGNER: Jeffrey Gobin
DISTRIBUTION: 500 pcs., Local

*This simple five-panel invitation takes advantage
of screen tints to enliven the palette of two PMS
colors chosen for this small print run project. The
background of twisting, turning threads is repeated
in various shades of blue on the reverse side.*

WARMEST WISHES CARDS

DESIGN FIRM: Worksight
LOCATION: New York, NY
CLIENT: Worksight
LOCATION: New York, NY
DESIGNER: Scott Santoro
PHOTOGRAPHER: Scott Santoro
DISTRIBUTION: 250 pcs., National

Each of the four 6" x 9" promotional postcards created by the studio uses a photograph shot by the designer. Single sided, two cards in the series are printed in black only and two are printed in PMS plus black.

T I P

Specialty papers and envelopes from the local stationer or art-supply store can add color and texture to your small print run design projects.

NEW

Diagram showing the extent and direction of flow of d through comn

SCOTT W SANTORO

Warmest Holiday Wishes from Scott & Emily at Worksi

brochures, catalogs, & direct mail

A vivid imagination, resourcefulness, and a healthy dose of ingenuity are keys to success when it comes to solving a brochure or catalog design problem. Many studios are not only downsizing formats but also resorting to existing imagery found in clip-art books, on stock-photo CD-ROMs, and in their or the clients' own archives. Improved digital camera and scanner technology has also bred a whole new source for imagery by allowing designers to create "scanographs" of objects in-house for use in layouts.

Low-cost digital printing on Indigo, Fiery, and laser printers, as well as masterful application of screened variations of two or three PMS colors are being combined with strong type, layout, and image solutions that don't require tight registration and extra-fine screening. Alternative

bindery solutions such as drilled pages assembled with spiral spines or screw posts are making projects that require numerous content changes over time cheaper to produce and update.

If the final product is intended for direct mail, there are additional challenges. The rising cost of postage and the need to reach large audiences can eat into a direct-mail project's budget. But hand assembly (executed by either the studio staff or the client), limited color palettes, and creative paper selection are quickly becoming viable solutions in this area of design.

Printing more than one piece of a direct-mail promotion on a single press sheet and paying for cuts rather than multiple press runs at the printer can drastically reduce production costs.

Because most printers charge by the number of impressions as well as for setup and clean-up costs, it's no wonder that it's less costly to produce three separate items by ordering 10,000 pieces with two cuts than ordering three separate runs of 10,000 pieces, each on smaller stock.

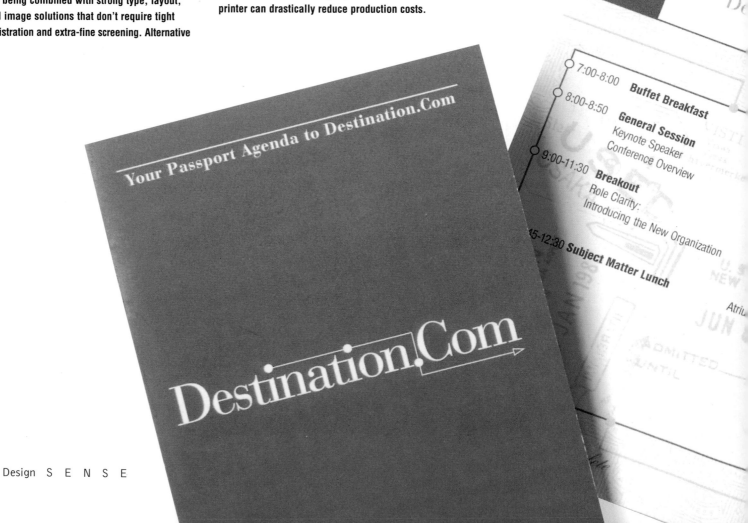

He who **will not** economize
will have to **agonize**.

—Confucius

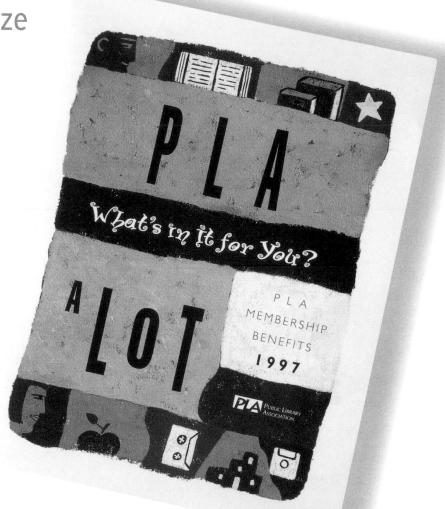

DESTINATION.COM

DESIGN FIRM: J. Graham Hanson Design
LOCATION: New York, NY
CLIENT: American Express
LOCATION: New York, NY
DESIGNER: J. Graham Hanson
DISTRIBUTION: 500 pcs., National

*Low-cost digital printing, a small format,
and existing images were the keys to
reducing the budget on this project. A
used passport was scanned to create the
interior images. And although this particular
annual project is usually produced in a
much larger format, the designer convinced
the client to try the passport concept. The
final four-color piece looks like a real pass-
port thanks to the natural characteristics of
digital printing.*

PLA MEMBERSHIP BENEFITS BROCHURE

DESIGN FIRM: Jim Lange Design
LOCATION: Chicago, IL
CLIENT: Public Library Association (PLA)
LOCATION: Chicago, IL
ART DIRECTOR: Kathleen Hughes
DESIGNER: Jim Lange
ILLUSTRATOR: Jim Lange
DISTRIBUTION: 10,000 pcs., National

*Imagery can convey strong messages even when
color and slickness might be lacking. The depth
and effectiveness of the individual paintings created
for and reproduced in this one-color project were
enhanced by the designer, who chose a rich PMS
color and a heavy-textured, uncoated text stock
as the perfect communications vehicles.*

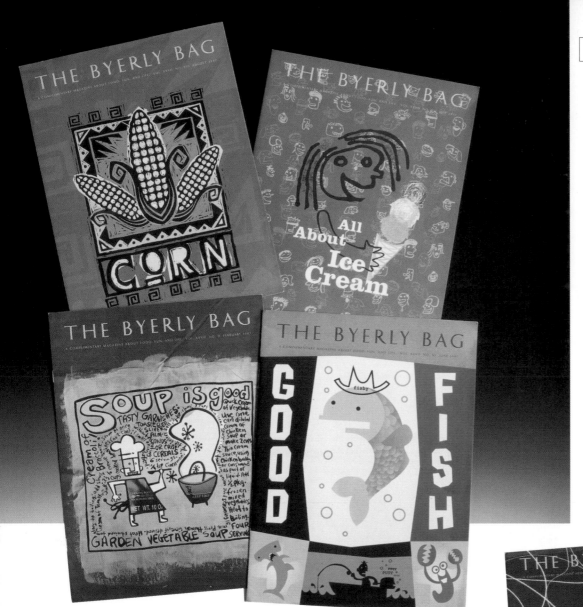

THE AUGUST 1997 BYERLY BAG

DESIGN FIRM: Design Center
LOCATION: Minnetonka, MN
CLIENT: Byerly's Food Stores
LOCATION: Edina, MN
ART DIRECTOR: John Reger
DESIGNER: Bill Flipson
DISTRIBUTION: 70,000 pcs., Local

This monthly house organ has three budgetary limitations. The design budget is limited to eight hours per month. It is printed on an inexpensive text stock. And the color budget is limited to three PMS hues. The designer's solution, however, addresses each limit. Strong, raw imagery is used for cover and text illustration, which eliminates reproduction concerns. The layout is comfortably formatted so text can be flowed into assigned areas each month, reducing labor time spent on production. And the designer has taken advantage of screening variations of the three chosen PMS colors to increase the color palette on each issue.

Nothing is cheap

which is superfluous,

for what one does

not need, is dear at a penny.

— P l u t a r c h

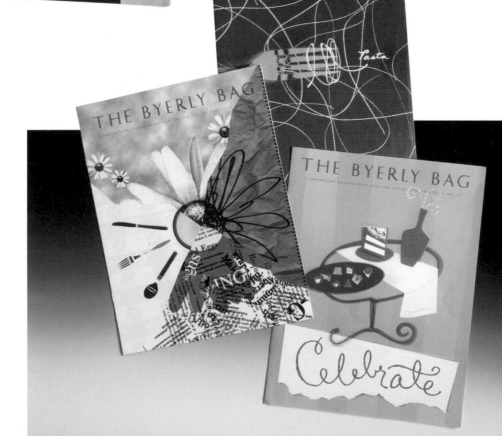

LABORATOIRES GARNIER PARIS BROCHURE

DESIGN FIRM: Giorgio Rocco Communications
LOCATION: Milan, Italy
CLIENT: Laboratoires Garnier Paris
LOCATION: Italy
ART DIRECTOR: Giorgio Rocco
DESIGNER: Giorgio Rocco
DISTRIBUTION: 300 pcs., National

A number of different identity program materials, including invitations, menus, notes, and this brochure, were generated out of one press sheet, which greatly reduced the production cost. The final pieces for the project were assembled and bound by hand at the studio.

SCHERTLER AUDIO TRANSDUCERS BROCHURE

DESIGN FIRM: Sagmeister, Inc.
LOCATION: New York, NY
CLIENT: Schertler Audio Transducers
LOCATION: Ligornetto, Switzerland
ART DIRECTOR: Stefan Sagmeister
DESIGNERS: Stefan Sagmeister, Eric Zim
ILLUSTRATOR: Eric Zim
PHOTOGRAPHER: Tom Schierlitz
DISTRIBUTION: 5,000 pcs., International

This brochure relies on the strength of photo selection, composition, and expressive typography to convey its message, which is printed in black and white on a coated text stock. The cover, however, is a two-color silk-screen printed on very inexpensive chipboard.

SYNERGY BROCHURE

DESIGN FIRM: Vaughn/Wedeen Creative
LOCATION: Albuquerque, NM
CLIENT: Synergy Group, Ltd.
LOCATION: Albuquerque, NM
ART DIRECTOR: Steve Wedeen
DESIGNERS: Steve Wedeen, Adabel Kaskiewicz
DISTRIBUTION: 2,000 pcs., National

Each of the six printed sheets that make up this spiral-bound brochure are printed three-on-two, using bright PMS colors. By printing each sheet with a different palette, the designers were able to expand the overall color scheme in the brochure without adding extra four-over-four color costs to the production budget.

POSTAL PACK FOR SECONDARY STUDENTS

DESIGN FIRM: Grafik Communications, Ltd.
LOCATION: Alexandria, VA
CLIENT: National Postal Museum
LOCATION: Washington, DC
ART DIRECTOR: Joe Barsin
DESIGNERS: Joe Barsin, Claire Wolfman, Judy Kirpich
DISTRIBUTION: 10,000 pcs., National

The three PMS colors used on the strong cover graphic lead the way to an interior that uses two PMS colors and employs screen tints throughout. All photographs were supplied by the museum from its archives. The cover illustration was created by the studio.

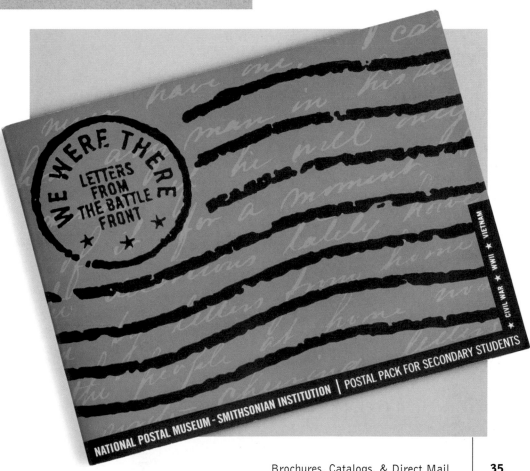

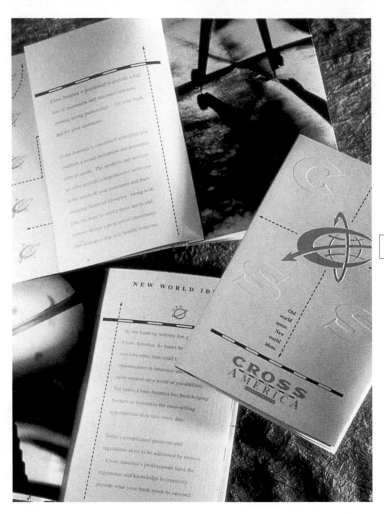

CROSS AMERICA CORPORATE BROCHURE

DESIGN FIRM: Sayles Graphic Design
LOCATION: Des Moines, IA
CLIENT: Cross America
LOCATION: Des Moines, IA
ART DIRECTOR: John Sayles
DESIGNER: John Sayles
ILLUSTRATOR: John Sayles
DISTRIBUTION: 500 pcs., National

The information in this financial services brochure changes frequently. But to keep the client from needing to commission a reprint every time, the designer developed a solution that allows quick updating at a low cost. The screw binding of this brochure allows the out-of-date pages to be removed and replaced as needed. The two-color palette further enhances the overall cost savings.

KOEHLER MCFADYEN & COMPANY BROCHURE

DESIGN FIRM: Hornall Anderson Design Works, Inc.
LOCATION: Seattle, WA
CLIENT: Koehler McFadyen & Company
LOCATION: Seattle, WA
ART DIRECTOR: Jack Anderson
DESIGNERS: Jack Anderson, Jana Wilson
PHOTOGRAPHER: Fred Houser
DISTRIBUTION: 2,500 pcs., Regional

The two-color design solution for this capabilities brochure takes advantage of economical duotone printing for the photographs, an uncoated pale-green tinted text stock for the body, a rich textured stock for the cover, and a strong layout to convey its message without costing a fortune.

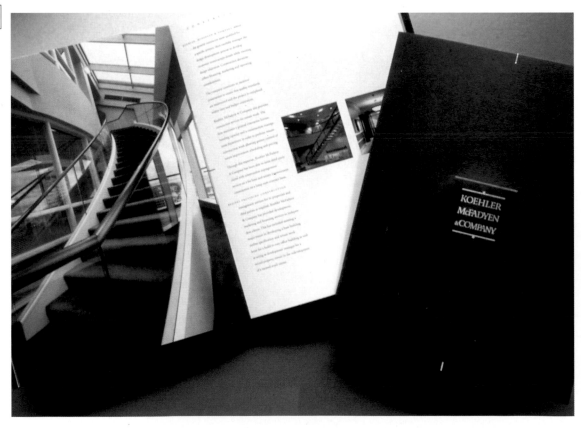

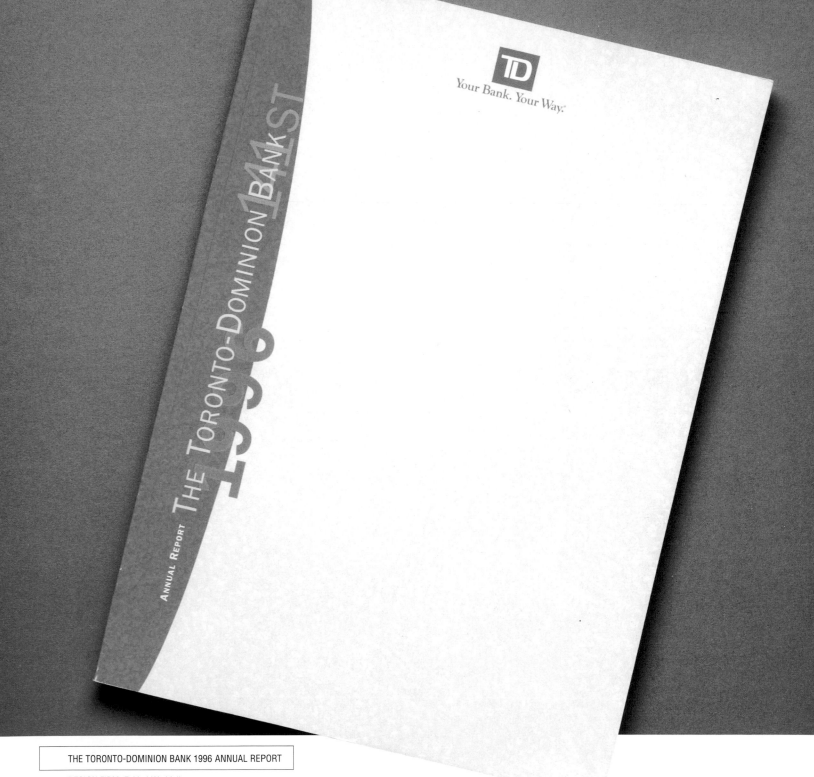

THE TORONTO-DOMINION BANK 1996 ANNUAL REPORT

DESIGN FIRM: Eskind Waddell
LOCATION: Toronto, ONT, Canada
CLIENT: The Toronto-Dominion Bank of Canada
LOCATION: Toronto, ONT, Canada
ART DIRECTOR: Roslyn Eskind
DESIGNERS: Roslyn Eskind, Gary Mansbridge, Nicola Lyon
DISTRIBUTION: 93,000 pcs., International

*Perfect binding allowed the three-color pages at the front of the
report to be tipped in at form breaks. Use of background screens,
textures, and tinted paper stock add further visual richness to
the one-color pages throughout.*

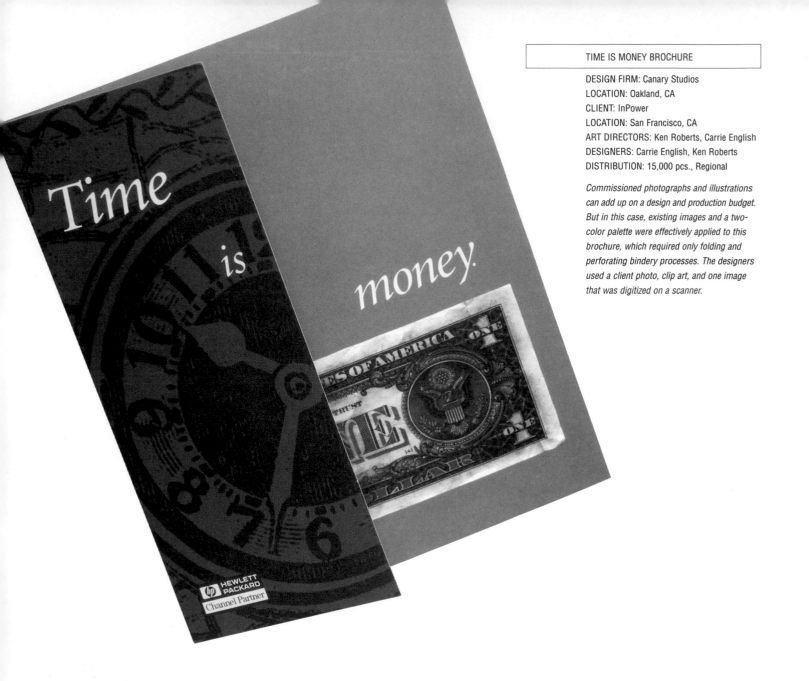

TIME IS MONEY BROCHURE

DESIGN FIRM: Canary Studios
LOCATION: Oakland, CA
CLIENT: InPower
LOCATION: San Francisco, CA
ART DIRECTORS: Ken Roberts, Carrie English
DESIGNERS: Carrie English, Ken Roberts
DISTRIBUTION: 15,000 pcs., Regional

Commissioned photographs and illustrations can add up on a design and production budget. But in this case, existing images and a two-color palette were effectively applied to this brochure, which required only folding and perforating bindery processes. The designers used a client photo, clip art, and one image that was digitized on a scanner.

THE INK TANK

DESIGN FIRM: Sagmeister, Inc.
LOCATION: New York, NY
CLIENT: The Ink Tank/R.O. Blechman
LOCATION: New York NY
ART DIRECTORS: Stefan Sagmeister
DESIGNERS: Stefan Sagmeister, Hjali Karlsson, Veronica Oh
ILLUSTRATORS: Mark Marek, et al.
PHOTOGRAPHERS: Various
DISTRIBUTION: 1,500 pcs., International

This one-color brochure is sent out with a 3/4" videotape as a promotional piece for a Manhattan animation house. The elements can be cut out to assemble a working zoetrope, enabling the viewing of the animation strips. The belly band that holds the brochure together is printed on the same paper stock as the rest of the piece.

THE NAPA REVIEW

21ST CENTURY-LEADERSHIP

A Publication of Napa Research · · · · · · · · · · · · · · · · · · Summer 1997

Rediscovering the Values-driven Organization

Why the Values-driven Organization?

Values-driven organizations are designed around a set of *core values*, and provide *products and services of value* to their customers. While the definition and context are new, the concept is anything but a management theory *du jour*. Examples of values-driven organizations exist in plain view on both the present and historical marketscape—Johnson and Johnson, Motorola, and Nordstrom, to name a few.

Before you put down this paper and say "heard it, done it," reflect on these questions: What is your organization's fundamental reason for being? Is there a guiding philosophy around which you base all decisions and strategies? What are the five or ten operating principles all of your employees agree on, embrace and live day to day?

In a values-driven organization, these answers roll off the tongue of every employee with excitement. Ultimately, the litmus test is not whether a vision statement exists in a memo filed away for posterity, but if, in fact, these guiding philosophies provide a *modus operandi* and ideological context for action. Committing to vision and values through systemic and structural means provides a link between what are often perceived as "soft" business concepts and the more traditional operating tools of strategic planning, reporting, and tactical implementation. The flexibility, adaptability and differentiation created by values-driven organizational design provide a significant competitive advantage in the new global marketplace.

The stroke of midnight, January 1, 2000, has become an increasingly cliché icon for the furious global change that is, in fact, already upon us. Falling international political and economic barriers have created a truly global marketplace. Democratic revolutions around the globe have been followed by the "democratization" of the workplace and its nomadic tribes of knowledge-workers. An unending cascade of technological innovations routinely brings industry-leading companies—witness Apple—to near obsolescence. And the bull market of the century has notched an unprecedented 50% growth in three years, on the heels of hundreds of technology and biotech IPOs.[1]

> *Vision, as a philosophy and imagined goal, is an interpretive tool to help deal with information overload.*

With this accelerated velocity of change, the opportunity cost of standing still has soared.

Onto this global historical stage, a particular type of organization has reemerged as a tried-and-true model for success and profitability: the values-driven organization.

[1] Clark, K., "Why You Should Worry About the Wealth Effect," *Fortune*, March 31, 1997: 24.

THE NAPA REVIEW

DESIGN FIRM: Wong Wong Boyack, Inc.
LOCATION: San Francisco, CA
CLIENT: The Napa Group
LOCATION: San Rafael, CA
ART DIRECTOR: Homan Lee
DESIGNER: Homan Lee
ILLUSTRATORS: Homan Lee,
Phuong-Mai Bui-Quang
DISTRIBUTION: 500 pcs., National

The design team saved illustration costs by creating one major shot and dividing it into quarters for use inside the brochure. The halftone image was modified using Adobe Photoshop filters, simulating what would have been a costly watercolor portrait.

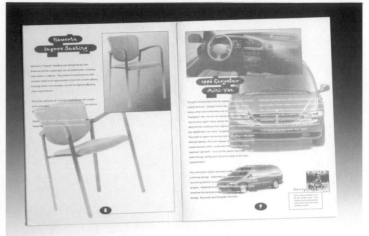

FORM FORUM

DESIGN FIRM: Barry Hutzel
LOCATION: Holland, MI
CLIENT: IDSA Michigan
LOCATION: Holland, MI
DESIGNER: Barry Hutzel
DISTRIBUTION: 1,000 pcs., International

This product-review issue was produced in one color on a textured, uncoated text stock and cover stock. A minimal wash-up charge was added to print the cover in black and the remainder of the project in a PMS color. All images were donated or pulled off the Internet from free files.

SMACNA ANNUAL CONVENTION
AND EXHIBITOR FORUM BROCHURE

DESIGN FIRM: Grafik Communications, Ltd.
LOCATION: Alexandria, VA
CLIENT: Sheet Metal and Air Conditioning
National Association
LOCATION: Chantilly, VA
DESIGNERS: Gretchen East, Susan English,
Judy Kirpich
DISTRIBUTION: 2,000 pcs., National

This project appears to be a four-color job, but two PMS colors (yellow and fuchsia) were blended to create the orange tints throughout the brochure. All photography was picked up from a stock-photo CD.

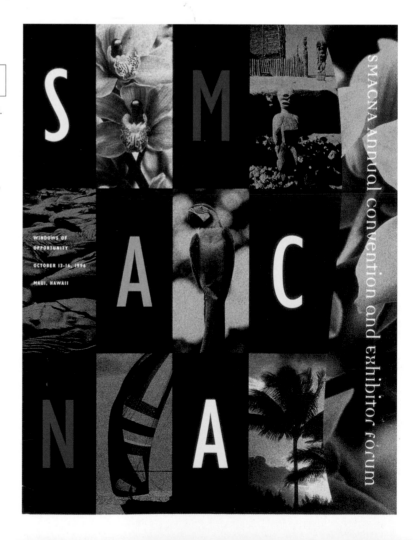

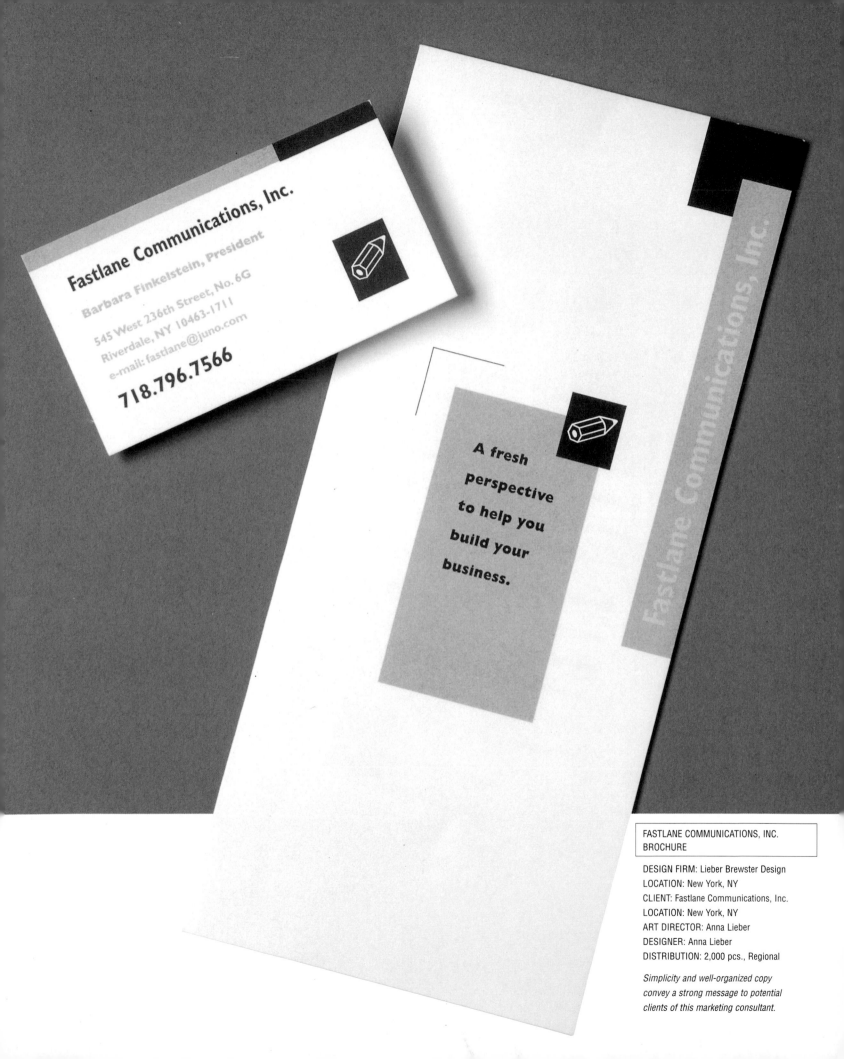

Fastlane Communications, Inc.

Barbara Finkelstein, President

545 West 236th Street, No. 6G
Riverdale, NY 10463-1711
e-mail: fastlane@juno.com

718.796.7566

A fresh
perspective
to help you
build your
business.

Fastlane Communications, Inc.

FASTLANE COMMUNICATIONS, INC.
BROCHURE

DESIGN FIRM: Lieber Brewster Design
LOCATION: New York, NY
CLIENT: Fastlane Communications, Inc.
LOCATION: New York, NY
ART DIRECTOR: Anna Lieber
DESIGNER: Anna Lieber
DISTRIBUTION: 2,000 pcs., Regional

*Simplicity and well-organized copy
convey a strong message to potential
clients of this marketing consultant.*

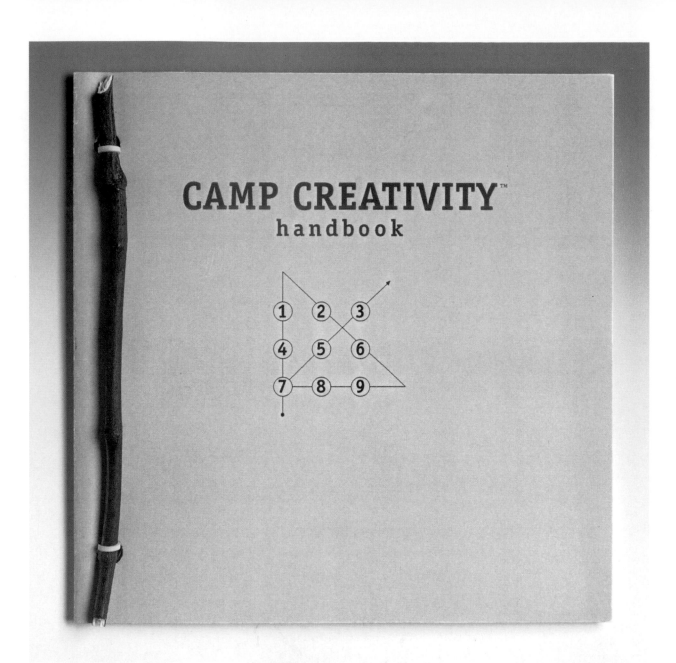

CAMP CREATIVITY HANDBOOK

DESIGN FIRM: Kiku Obata & Company
LOCATION: St. Louis, MO
CLIENT: Bradshaw Marketing Resources
LOCATION: St. Louis, MO
ART DIRECTOR: Terry Bliss
DESIGNER: Jeff Rifkin
DISTRIBUTION: 55 pcs., Local

Printed in-house on a color copier, this four-color, 24-page plus cover brochure was bound together by the studio staff with twigs gathered from the parking lot. The photographs appearing liberally throughout the piece were pulled from public-domain stock photography found on the studio's photo CD collection.

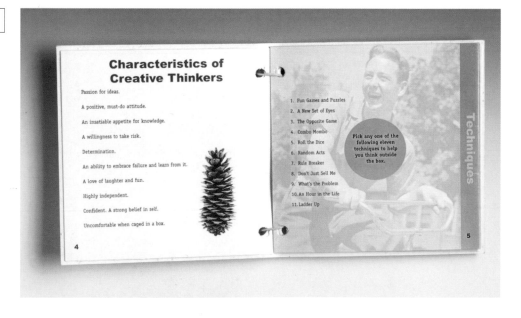

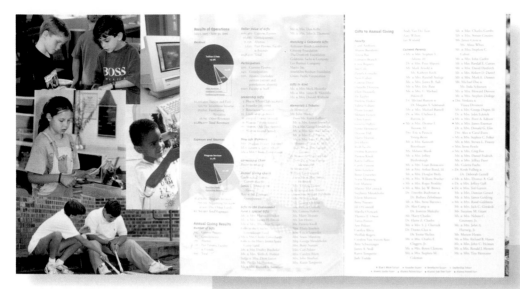

THE COMMUNITY SCHOOL
1995-1996 ANNUAL REPORT

DESIGN FIRM: Kiku Obata & Company
LOCATION: St. Louis, MO
CLIENT: The Community School
LOCATION: St. Louis, MO
ART DIRECTOR: Amy Knopf
DESIGNER: Amy Knopf
DISTRIBUTION: 1,500 pcs., Local

The turn-of-the-century technique for hand-tinting photographs made a resurgence during the early 1970s on rock-and-roll album covers and posters. And this same warm, friendly, visual approach was applied by this annual report's designer on the double gatefold four-color cover. The photomontage was created with black-and-white versions of the school's archival photos, which were tinted by the designer. The report's interior was printed in one PMS color on a tinted text paper stock to further reduce costs.

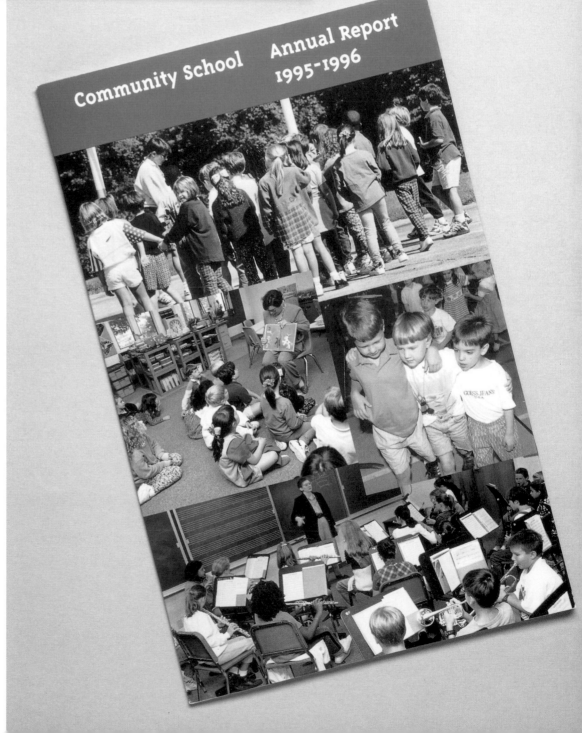

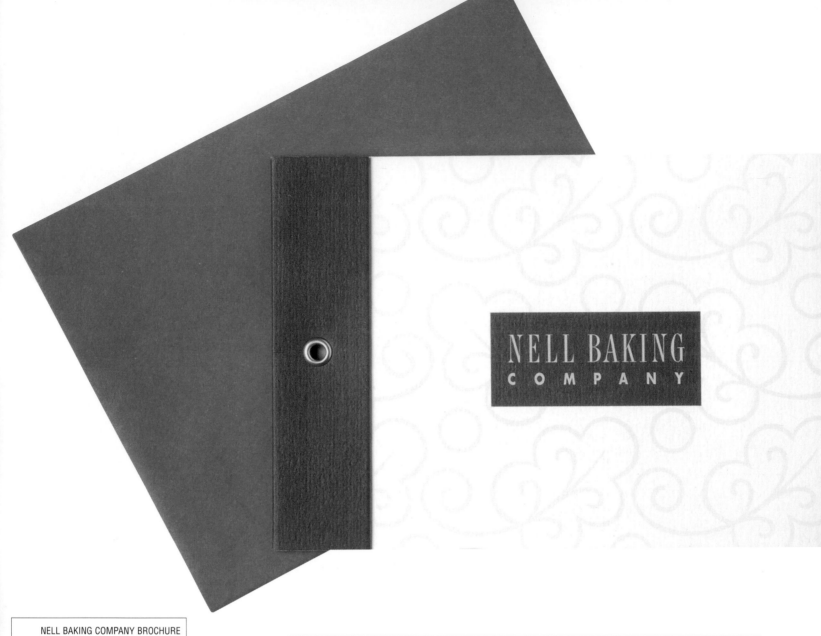

NELL BAKING COMPANY BROCHURE

DESIGN FIRM: Lambert Design
LOCATION: Dallas, TX
CLIENT: Nell Baking Company
LOCATION: Kenedy, TX
ART DIRECTOR: Christie Lambert
DESIGNER: Christie Lambert
ILLUSTRATOR: Christie Lambert
DISTRIBUTION: 1,500 pcs., National

When the studio printed the four-color labels for this bakery's newest products, there was enough space remaining on the press sheet to print the full-color interior of this small-format product brochure. All of the art was computer-generated, so outside color separation and film costs never figured into the overall budget. The pages were printed on one side and folded to produce a front and back. The covers and the vellum flysheets were printed at a small quick-print house. The assembled pieces were bound together with a rivet.

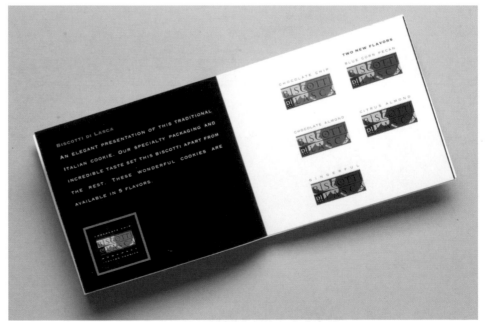

EASTER SEALS 1995-1996 ANNUAL REPORT

DESIGN FIRM: Kiku Obata & Company
LOCATION: St. Louis, MO
CLIENT: Missouri Easter Seal Society
LOCATION: St. Louis, MO
ART DIRECTOR: Liz Sullivan
DESIGNER: Liz Sullivan
PHOTOGRAPHER: Easter Seal Society clients
DISTRIBUTION: 3,000 pcs., Regional

Original photography can take a large chunk out of a project's budget and doesn't always convey the warmth and personality desired. The candid shots used to illustrate this annual report were taken by the nonprofit organization's clients using disposable cameras that were donated by a local photo shop. Paired with a striking two-color text palette and donated paper stock, a friendly, heartwarming look was achieved for very little money.

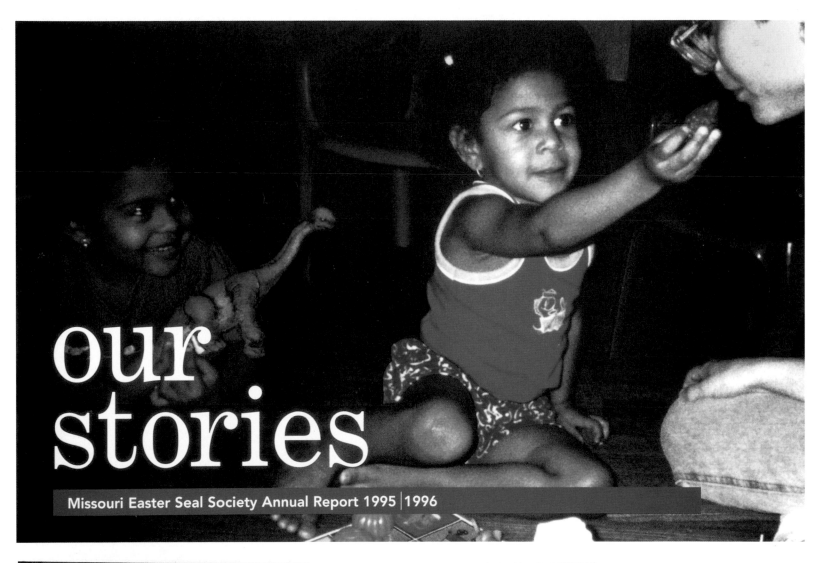

our stories

Missouri Easter Seal Society Annual Report 1995 | 1996

Chris loves the computer and attends every computer class he can find.

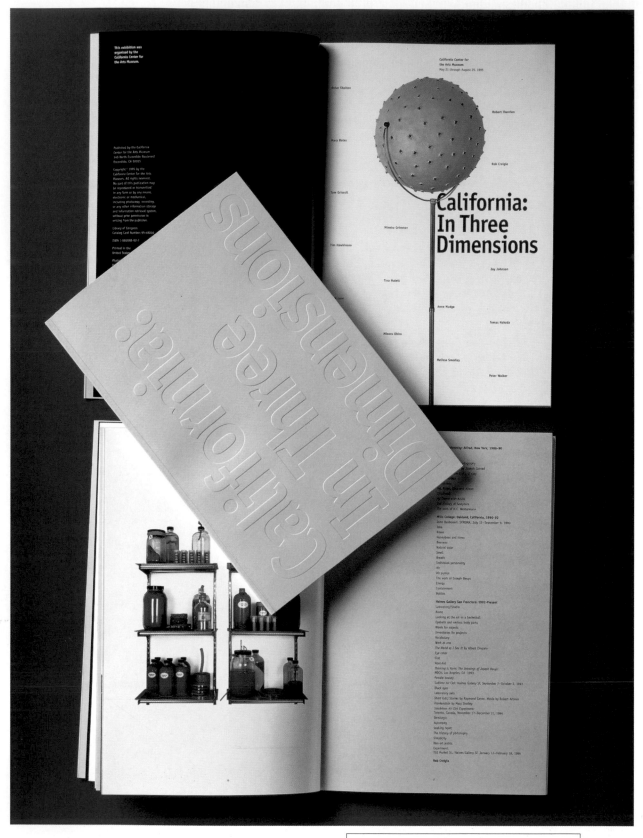

CALIFORNIA IN THREE DIMENSIONS
EXHIBITION CATALOG

DESIGN FIRM: Mires Design
LOCATION: San Diego, CA
CLIENT: California Center for the Arts
LOCATION: Escondido, CA
ART DIRECTOR: John Ball
DESIGNERS: Deborah Horn, John Ball
DISTRIBUTION: 2,000 pcs., National

Despite its pricey appearance, this catalog for an exhibition of big, bright, contemporary sculpture was economically produced. The cover was embossed and debossed on an unprinted cover stock. The four-color photography pages were ganged up and printed separately from the single-color text pages. The entire project was then interleaved and notch bound.

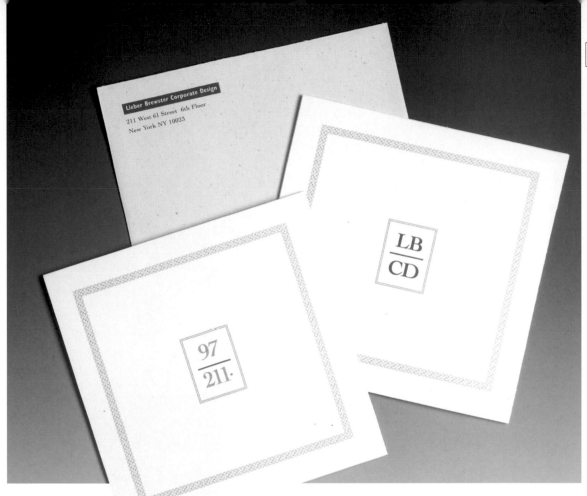

LB.CD AND 97.211 CAMPAIGN

DESIGN FIRM: Lieber Brewster Design
LOCATION: New York, NY
CLIENT: Lieber Brewster Design
LOCATION: New York, NY
ART DIRECTOR: Anna Lieber
DESIGNER: Anna Lieber
DISTRIBUTION: 500 pcs., Regional

The studio only needed 500 holiday/ moving cards, so to make the project cost-effective, a networking response card was ganged up on the same sheet. The same printed envelopes were used for both mailings.

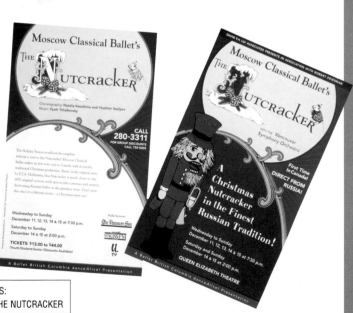

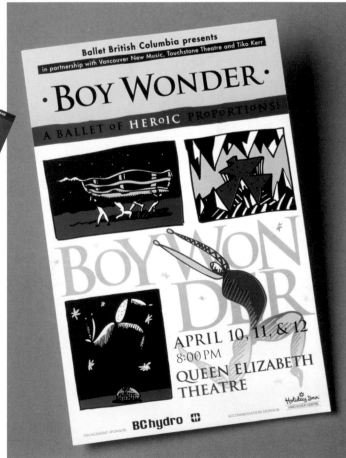

CONCERT FLYERS:
BOY WONDER/THE NUTCRACKER

DESIGN FIRM: Moondog Studios, Inc.
LOCATION: Vancouver, BC, Canada
CLIENT: Ballet British Columbia
LOCATION: Vancouver, BC, Canada
ART DIRECTOR: Derek von Essen
DESIGNER: Derek von Essen
ILLUSTRATOR: Tiko Kerr
DISTRIBUTION: 20,000 and 10,000 pcs., Regional

Printing more than one piece per sheet and paying for a single cut at the printer can drastically reduce production costs. These two-sided concert flyers were printed two up on 8.5" x 11" coated text sheets in two to four PMS colors on one side and one PMS color on the other. But rather than paying for 20,000 impressions in press time, the budget was reduced by pricing out for 10,000 pieces.

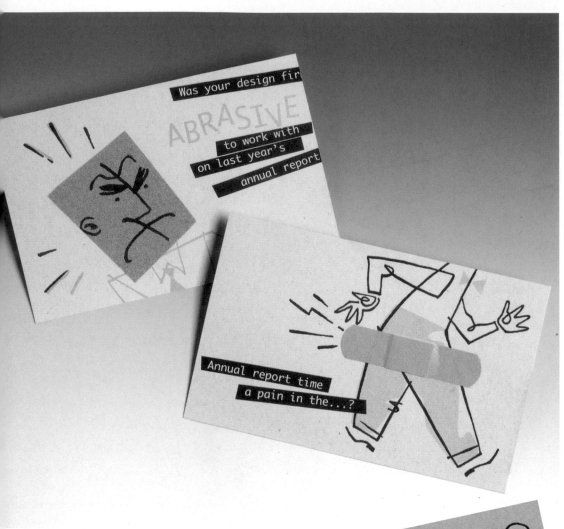

POSTCARDS:
ABRASIVE/ DRAIN/ MONSTER/ PAIN IN THE ASS

DESIGN FIRM: Design Center
LOCATION: Minnetonka, MN
CLIENT: Design Center
LOCATION: Minnetonka, MN
ART DIRECTOR: John Reger
DESIGNER: Sherwin Schwartzrock
DISTRIBUTION: 500 pcs., Local

Small print runs and willing hands can create some entertaining effects with minimal labor time. Each of the pieces in this postcard project were printed in two colors on both sides, on an uncoated card stock. The sandpaper drawings, punched holes, staples, and adhesive bandages were added to the cards at the studio.

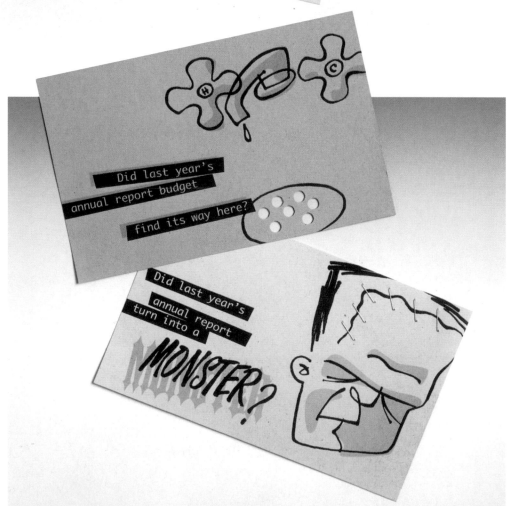

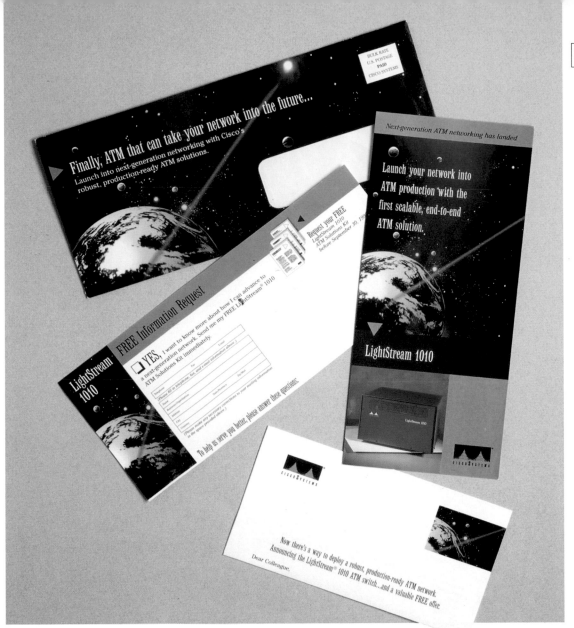

CISCO LIGHTSTREAM 1010

DESIGN FIRM: Wong Wong Boyack, Inc.
LOCATION: San Francisco, CA
CLIENT: Cisco Systems, Inc.
LOCATION: San Jose, CA
ART DIRECTORS: Ben Wong, Jennifer Porter
DESIGNER: Jennifer Porter
ILLUSTRATOR: Michael Frandy
DISTRIBUTION: 15,000 pcs., National

A simple short print-run economy that can maximize potential is ganging up more than one printed piece onto a single press sheet. (Costs were substantially less than with three separate print runs.) Carefully sized so that all three pieces of this four-color direct mail package fit into an oversized envelope, the entire package was printed on a single large sheet.

COPELAND REIS MAILER (WOMEN & MEN)

DESIGN FIRM: Mires Design
LOCATION: San Diego, CA
CLIENT: Copeland Reis Talent Agency
LOCATION: San Diego, CA
ART DIRECTOR: John Ball
DESIGNER: John Ball, Miguel Perez
PHOTOGRAPHER: Various
DISTRIBUTION: 1,000 pcs., Local

Printed on a sturdy coated card stock, this six-fold, black-and-white direct mail piece was designed to economically accentuate the agency's most valuable assets: the appearance of its male and female models.

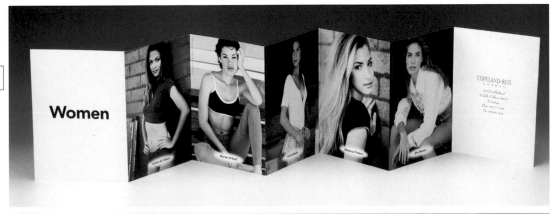

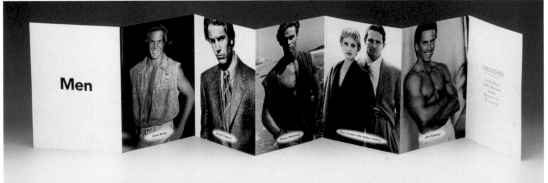

corporate identity

A trend toward minimal color and "greenness" is changing the way designers develop identities for their clients. Many of these programs employ only two PMS colors, and some are even intentionally developed as striking black-and-white solutions. The efficiency of non-traditional printing methods such as photocopiers, inkjet printers, laser printers, Iris and other digital printers, as well as the availability of specialty paper stocks, have made letterhead, business cards, and other business forms more affordable and easier to customize for client use. Recycled and kraft papers are also becoming popular stock selections for identity programs, presenting an environment- and cost-conscious image for the client.

Seemingly complex projects such as monthly newsletters or regularly updated marketing materials can be cost-effectively produced. Pre-printed, full-color shells, that contain the company's logo and boilerplate information in two or more colors, are saving small budgets by allowing clients to print limited quantities as single color jobs–rather than costing out for a high-priced, three-color run every time an issue is published.

A NIGHT AT THE MOVIES

DESIGN FIRM: J. Graham Hanson Design
LOCATION: New York, NY
CLIENT: AIGA/NY
LOCATION: New York, NY
ART DIRECTOR: J. Graham Hanson
DESIGNERS: J. Graham Hanson, Iris Ted
ILLUSTRATORS: J. Graham Hanson, Iris Ted
DISTRIBUTION: 1,000 pcs., Local

Creating original images on a scanner can produce some fascinating and economical effects. A piece of exposed 35 mm film was adhered to a curved bristol board and placed on its side on a flatbed scanner. The resulting image was used as a logo for this invitation.

A Night at the Movies
PRESENTED BY AIGA NEW YORK AND POTLATCH 17 SEPTEMBER 1996

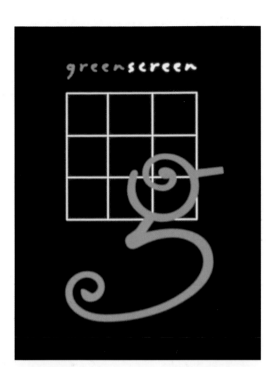

GREENSCREEN LOGO

DESIGN FIRM: Selbert Perkins Design
LOCATION: Cambridge, MA
CLIENT: Greenscreen
LOCATION: Los Angeles, CA
ART DIRECTOR: Robin Perkins
DESIGNERS: Robin Perkins, Heather Watson
DISTRIBUTION: National

A simple design solution was the key element that allowed the designers to maintain a very reasonable design and production budget for this corporate identity. The g came from the client's existing identity and proprietary typeface. The entire identity was designed for two-color printing.

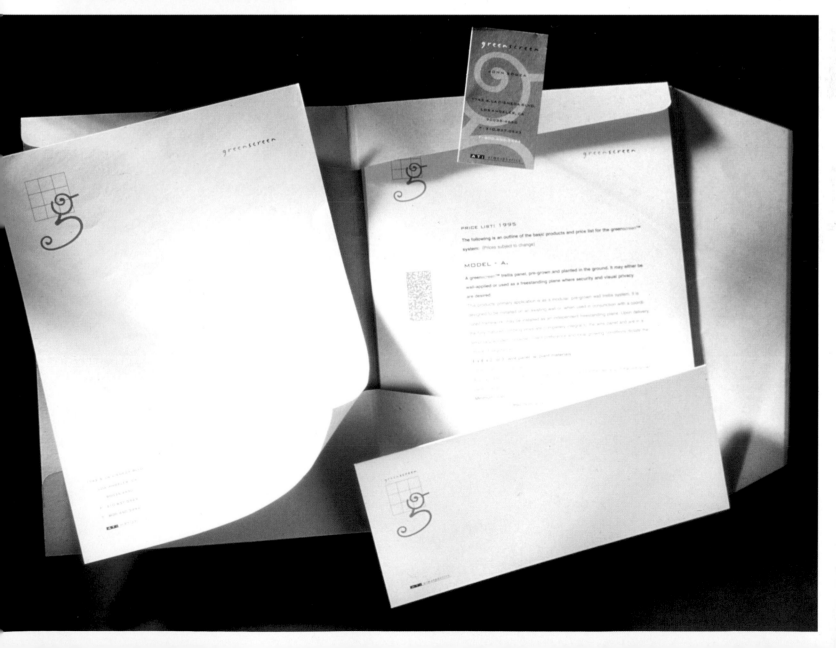

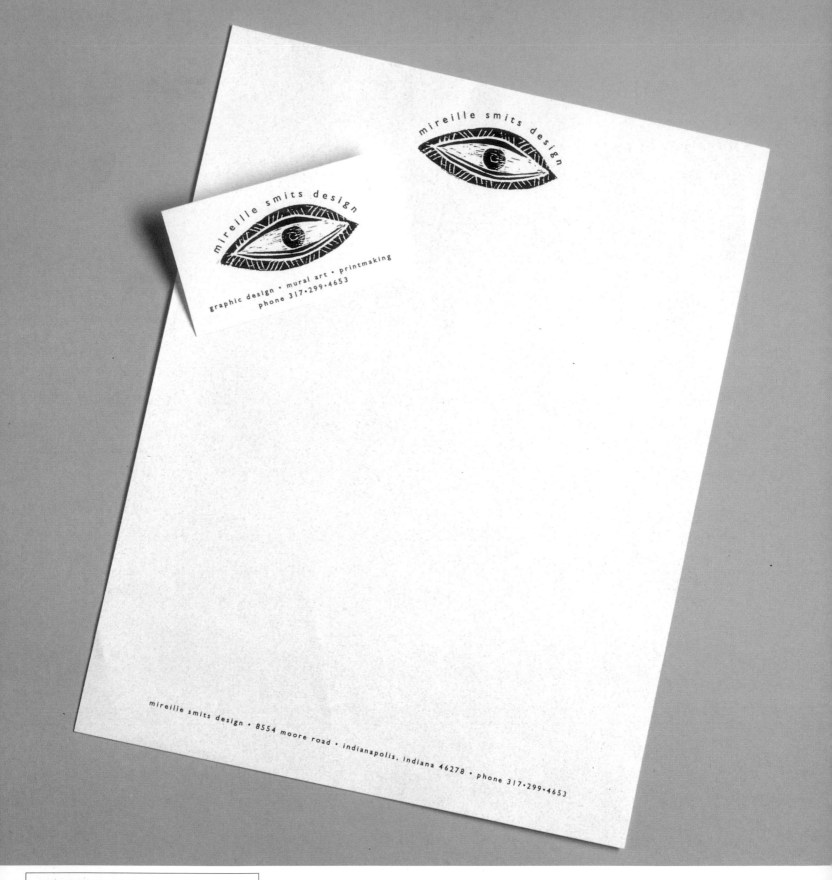

MIREILLE SMITS DESIGN

DESIGN FIRM: Mireille Smits Design
LOCATION: Indianapolis, IN
CLIENT: Mireille Smits Design
LOCATION: Indianapolis, IN
DESIGNER: Mireille Smits
ILLUSTRATOR: Mireille Smits
DISTRIBUTION: 200 pcs., National

The efficiency of non-traditional printing methods has entered the consciousness of some designers. Photocopiers, inkjet printers, laser printers, Iris and other digital printers have made print jobs more affordable as the machinery has been improved over time. This letterhead and business card were designed to be printed on a photocopier using off-the-shelf specialty paper stocks.

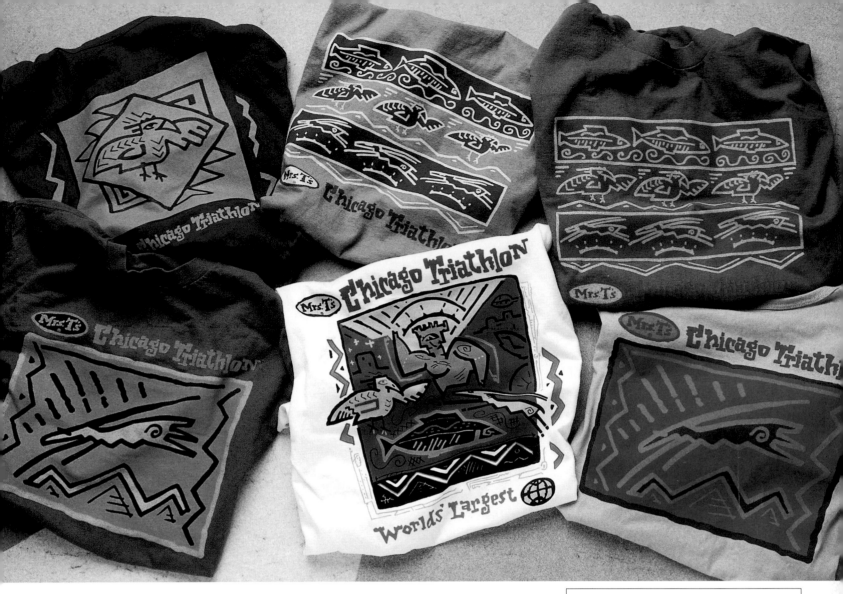

DESIGN FIRM: Jim Lange Design
LOCATION: Chicago, IL
CLIENT: Mrs. T's Chicago Triathlon
LOCATION: Chicago, IL
ART DIRECTOR: Jan Caille
DESIGNER: Jim Lange
ILLUSTRATOR: Jim Lange
DISTRIBUTION: 4,000 pcs., Local

Value-added design also helps defray the costs of producing a promotional piece. This collection of eight designs (not all pictured) was printed in different inks and on different colors and types of shirts. Some of the T-shirts were worn by participants and volunteers at this event, which included over 4,000 triathletes. The T-shirts, sold at the event to defray the design and production costs, also proved to be a strong branding mechanism for future events.

Voetreflexzone massage
Metamorfose &
Chakra massage

Margje van der Weide
Hefveld 4
5642 DC Eindhoven
Tel. 040-2813169

MARGJE VAN DER WEIDE BUSINESS CARD

DESIGN FIRM: Mireille Smits Design
LOCATION: Indianapolis, IN
CLIENT: Margje van der Weide Reflexology Massage
LOCATION: Eindhoven, The Netherlands
DESIGNER: Mireille Smits
ILLUSTRATOR: Mireille Smits
DISTRIBUTION: 200 pcs., International

The business cards for this project were printed on a photocopier using off-the-shelf specialty paper stock. But color was achieved by hand-tinting each piece with watercolor paints.

Corporate Identity | **53**

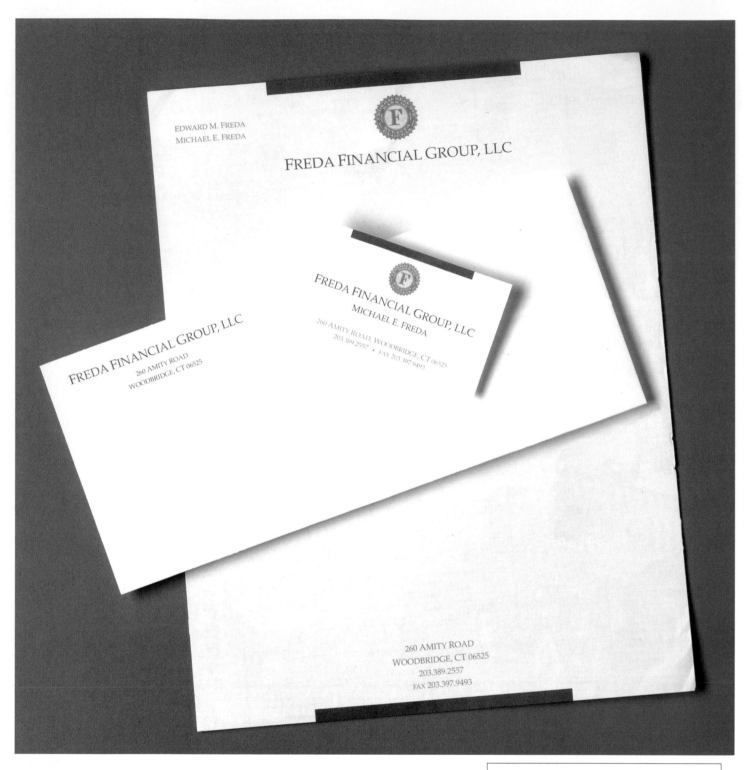

EDWARD M. FREDA
MICHAEL E. FREDA

FREDA FINANCIAL GROUP, LLC

FREDA FINANCIAL GROUP, LLC
MICHAEL E. FREDA
260 AMITY ROAD, WOODBRIDGE, CT 06525
203.389.2557 • FAX 203.397.9493

FREDA FINANCIAL GROUP, LLC
260 AMITY ROAD
WOODBRIDGE, CT 06525

260 AMITY ROAD
WOODBRIDGE, CT 06525
203.389.2557
FAX 203.397.9493

FREDA FINANCIAL GROUP, LLC IDENTITY

DESIGN FIRM: Atlantic Design Works
LOCATION: West Hartford, CT
CLIENT: Freda Financial Group, LLC
LOCATION: Woodbridge, CT
ART DIRECTOR: Stacy W. Murray
DESIGNER: Stacy W. Murray
DISTRIBUTION: 1,000 pcs., Local

This one-color design job was printed on paper stock the printer had on hand. Using a PMS green ink and a scanned grayscale image off a dollar bill, the designer created a feeling of depth without too much embellishment.

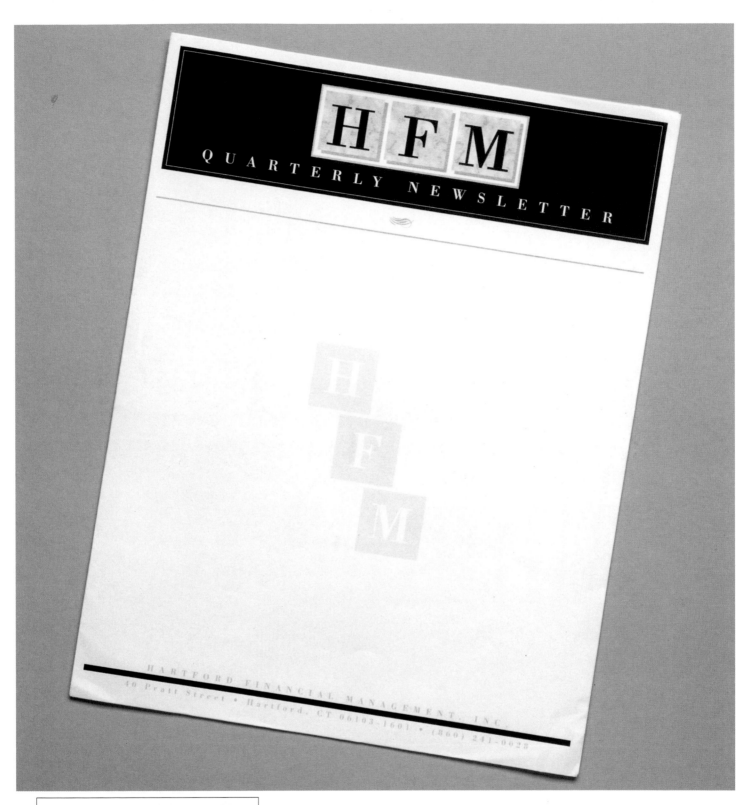

HARTFORD FINANCIAL MANAGEMENT

DESIGN FIRM: Atlantic Design Works
LOCATION: West Hartford, CT
CLIENT: Hartford Financial Management
LOCATION: Hartford, CT
ART DIRECTOR: Stacy W. Murray
DESIGNER: Stacy W. Murray
DISTRIBUTION: 8,000 pcs., National

Projects that have a continuous run of changing information don't have to cost more because the client wants color. Brochures, product-information sheets, and even newsletters can be printed as needed on pre-printed shells that can contain the company's logo, address, or other boilerplate information in two or more colors. This newsletter has a limited print run of a few hundred issues per quarter. To save the expense of producing a three-color publication, the designer created a two-color shell on which the publisher prints black text as a single-color print job. It is also designed to fold as a self-mailer.

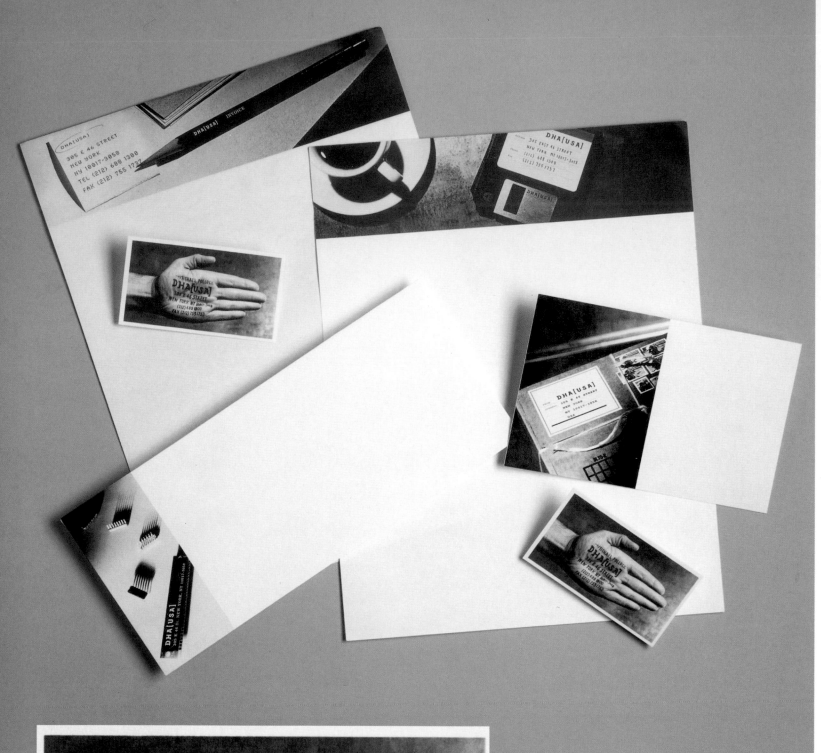

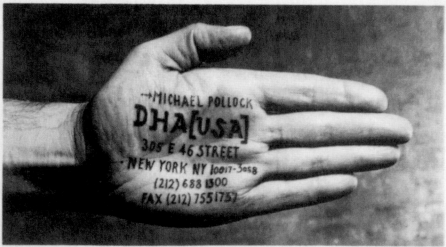

DHA (USA)

DESIGN FIRM: Sagmeister, Inc.
LOCATION: New York, NY
CLIENT: DHA (USA)
LOCATION: New York, NY
ART DIRECTOR: Stefan Sagmeister
DESIGNER: Stefan Sagmeister
PHOTOGRAPHER: Tom Schierlitz
DISTRIBUTION: 3,000 pcs., National

*Who says black-and-white design is dull?
This entire identity program is executed in
black and white. Typesetting costs were also
practically nil because the type actually
appears on the props in each photograph.*

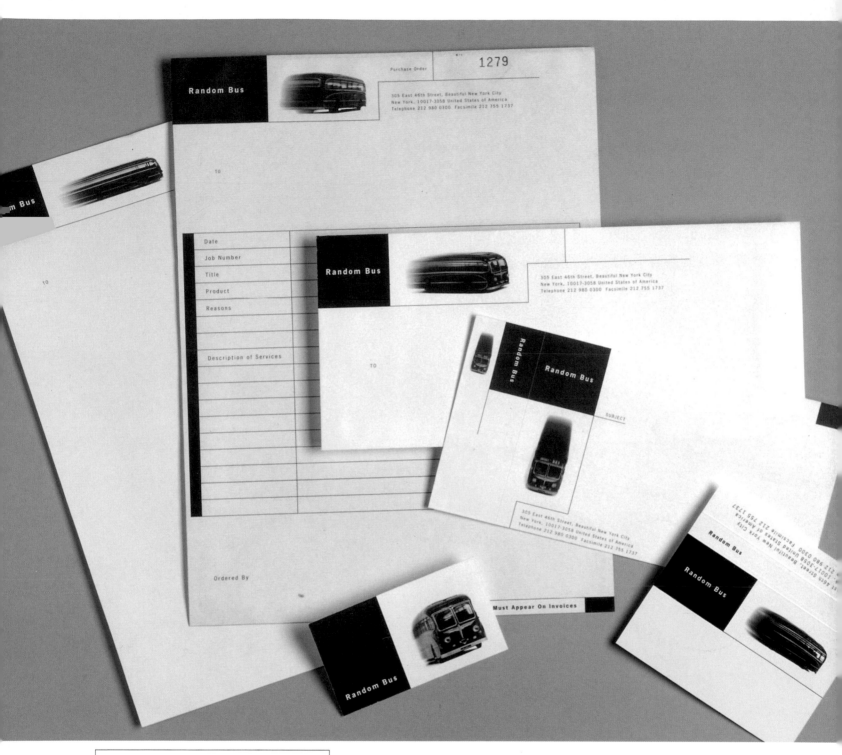

RANDOM BUS

DESIGN FIRM: Sagmeister, Inc.
LOCATION: New York, NY
CLIENT: Random Bus
LOCATION: New York, NY
ART DIRECTOR: Stefan Sagmeister
DESIGNER: Eric Zim
ILLUSTRATOR: Eric Zim
PHOTOGRAPHER: Tom Schierlitz
DISTRIBUTION: 3,000 pcs., National

This identity program is executed entirely in
black and white, from the business cards,
carbonless forms, cassette-tape covers, and
shipping labels to envelopes and letterhead.

TOM SCHIERLITZ LETTERHEAD

DESIGN FIRM: Sagmeister, Inc.
LOCATION: New York, NY
CLIENT: Tom Schierlitz
LOCATION: New York, NY
ART DIRECTOR: Stefan Sagmeister
DESIGNER: Stefan Sagmeister
DISTRIBUTION: 2,000 pcs., International

*The business card in this all black-and-white
identity program has a die-cut hole punched
out of the center, its only outstanding cost.*

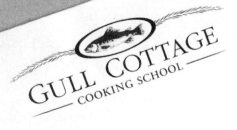

GULL COTTAGE
COOKING SCHOOL

GULL COTTAGE
COOKING SCHOOL

British Columbia V0R 1Z0

CATHERINE STAUBER *Proprietor* TEL: (250) 335-0199

4980 Kirk Road
Sandpiper, Hornby Island
British Columbia V0R 1Z0

Arthur's Farm 5-2
Hornby Island
British Columbia V0R 1Z0

TEL: (250) 335-0199

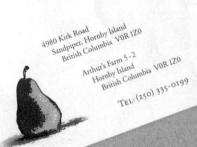

GULL COTTAGE COOKING SCHOOL IDENTITY

DESIGN FIRM: Moondog Studios, Inc.
LOCATION: Vancouver, BC, Canada
CLIENT: Gull Cottage Cooking School
LOCATION: Hornby Island, BC, Canada
ART DIRECTORS: Derek von Essen, Odette Hidalgo
DESIGNERS: Odette Hidalgo, Derek von Essen
ILLUSTRATOR: Derek von Essen
DISTRIBUTION: 1,000 pcs., Regional

This entire identity program was created in two PMS colors, including the letterhead, business card, and envelope. Extra calendar shells were printed so the client could print new course dates in one color as needed at a nominal cost.

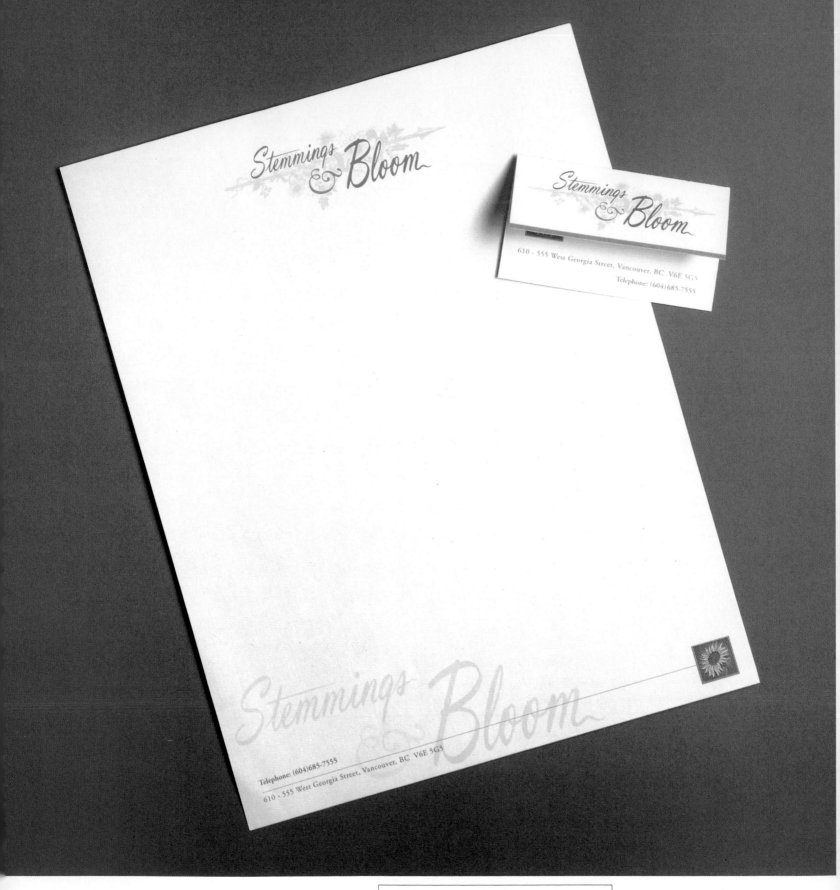

STEMMINGS & BLOOM IDENTITY

DESIGN FIRM: Moondog Studios, Inc.
LOCATION: Vancouver, BC, Canada
CLIENT: Stemmings & Bloom
LOCATION: Vancouver, BC, Canada
ART DIRECTORS: Derek von Essen, Odette Hidalgo
DESIGNERS: Odette Hidalgo, Derek von Essen

ILLUSTRATOR: Odette Hidalgo
DISTRIBUTION: 1,000 pcs., Regional

*This entire identity package for a florist was
designed in two PMS colors, taking advantage
of screens to add depth to the images.*

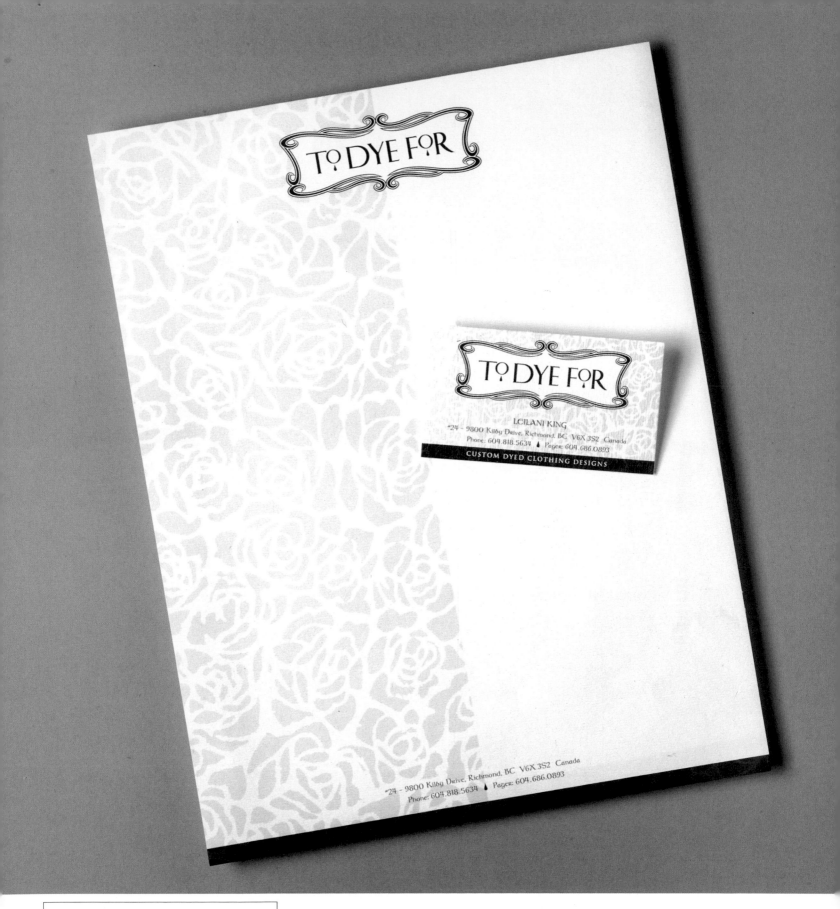

TO DYE FOR IDENTITY

DESIGN FIRM: Moondog Studios, Inc.
LOCATION: Vancouver, BC, Canada
CLIENT: To Dye For
LOCATION: Vancouver, BC, Canada
ART DIRECTOR: Odette Hidalgo
DESIGNER: Odette Hidalgo

ILLUSTRATOR: Odette Hidalgo
DISTRIBUTION: 500 pcs., Regional

This entire identity package for a fabric designer was developed using one PMS and applying screens to add depth.

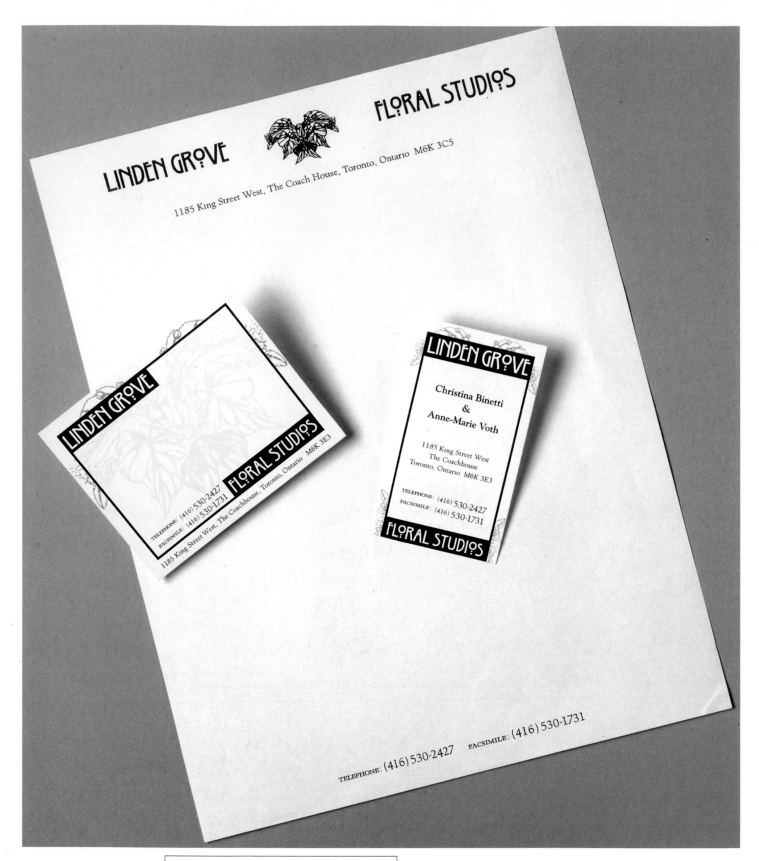

LINDEN GROVE FLORAL STUDIOS IDENTITY

DESIGN FIRM: Moondog Studios, Inc.
LOCATION: Vancouver, BC, Canada
CLIENT: Linden Grove Floral Studios
LOCATION: Toronto, ONT, Canada

ART DIRECTOR: Odette Hidalgo
DESIGNER: Odette Hidalgo
ILLUSTRATOR: Odette Hidalgo
DISTRIBUTION: 1,000 pcs., Local

This entire identity for a florist relies on black plus one PMS color. The business cards and hang tags were ganged two up on 8.5" x 11" sheets. The letterhead is printed on an inkjet by the client for further cost savings.

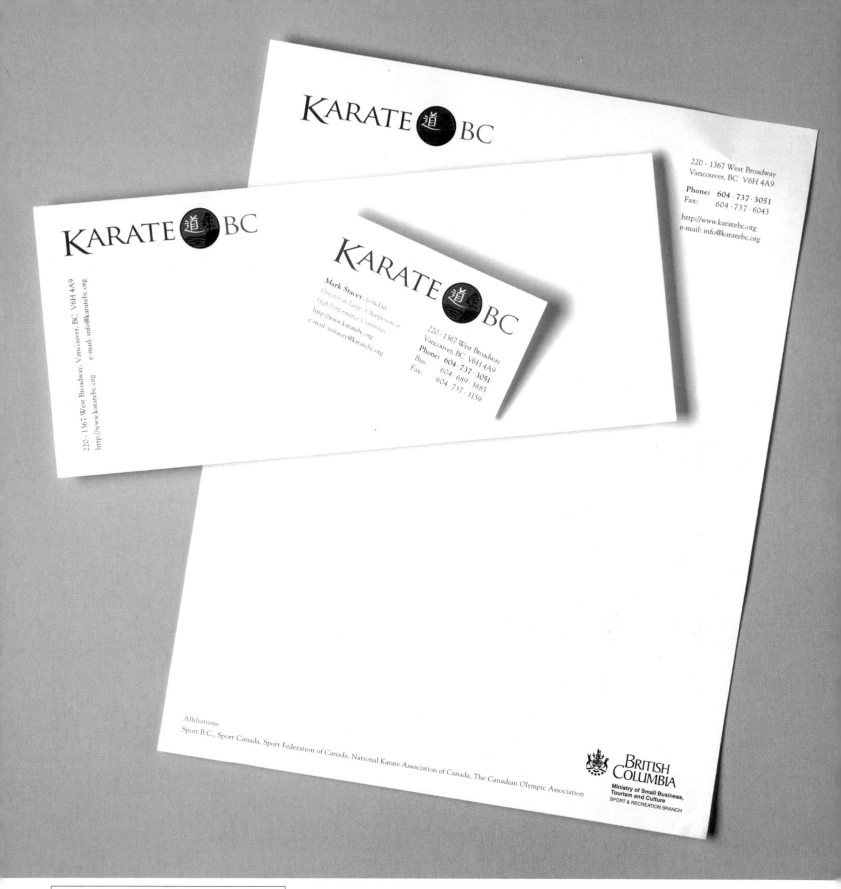

KARATE BC IDENTITY

DESIGN FIRM: Moondog Studios, Inc.
LOCATION: Vancouver, BC, Canada
CLIENT: Karate BC
LOCATION: Vancouver, BC, Canada

ART DIRECTORS: Derek von Essen, Odette Hidalgo
DESIGNERS: Odette Hidalgo, Derek von Essen
ILLUSTRATOR: Odette Hidalgo
DISTRIBUTION: 1,000 pcs., Regional

This two-color identity program for a karate school was designed using black plus one PMS color, avoiding the use of bleeds to further reduce costs.

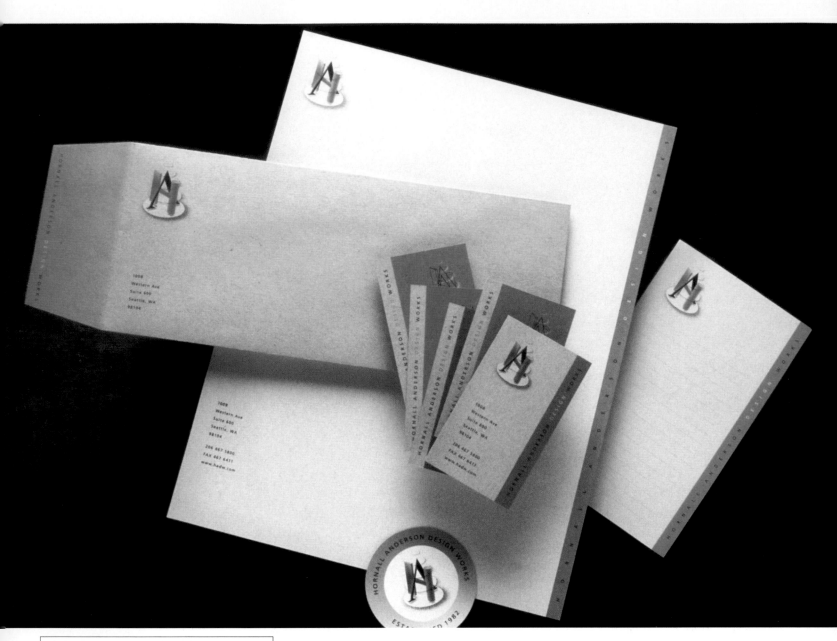

HORNALL ANDERSON DESIGN WORKS LETTERHEAD

DESIGN FIRM: Hornall Anderson Design Works, Inc.
LOCATION: Seattle, WA
CLIENT: Hornall Anderson Design Works, Inc.
LOCATION: Seattle, WA
ART DIRECTOR: Jack Anderson
DESIGNERS: Jack Anderson, David Bates
ILLUSTRATOR: David Bates
DISTRIBUTION: International

*The new Hornall Anderson Design Works identity
system employs an inexpensive, natural, recyclable
paper stock for the envelopes, labels, business
cards, and even the letterhead itself.*

T I P

*Try to gang up more than one piece per sheet whenever possible to
reduce costs. Most printers cost out jobs by the number of impressions
run. Therefore, 10,000 copies and one cut will cost you far less than
20,000 copies and no cuts.*

DESIGN FIRM: Vaughn/Wedeen Creative
LOCATION: Albuquerque, NM
CLIENT: Massage for the Health of It
LOCATION: Albuquerque, NM
ART DIRECTOR: Rick Vaughn
DESIGNER: Rick Vaughn
PHOTOGRAPHER: Michael Barley
DISTRIBUTION: Regional

Using black ink and three primary paper stock colors, the designer created the feel of vibrant full color throughout the letterhead, envelopes, and business cards.

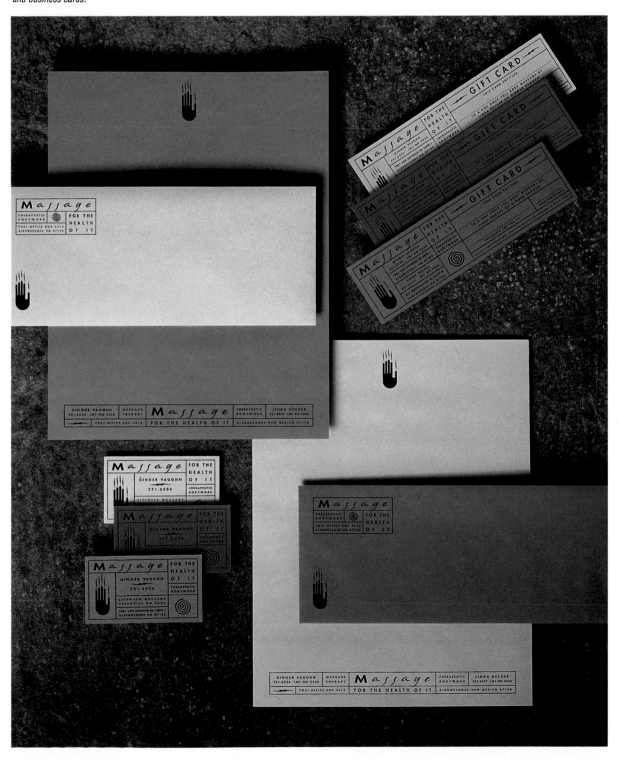

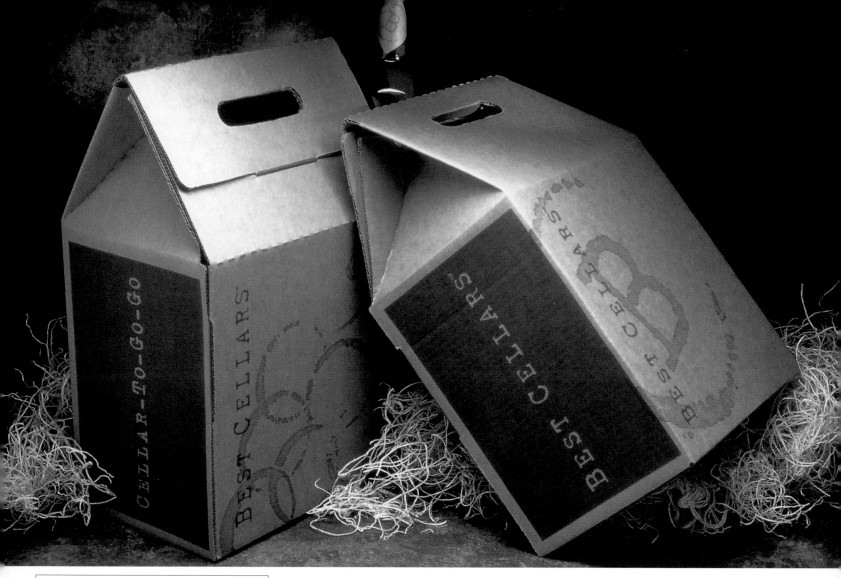

BEST CELLARS CORPORATE IDENTITY

DESIGN FIRM: Hornall Anderson Design Works, Inc.
LOCATION: Seattle, WA
CLIENT: Best Cellars
LOCATION: New York, NY
ART DIRECTOR: Jack Anderson
DESIGNERS: Jack Anderson, Lisa Cerveny, Jana Wilson
DISTRIBUTION: National

A simple logo design based on a stain left by a wine bottle on a linen tablecloth is applied throughout the entire identity program, which uses inexpensive recyclable kraft stock throughout its packaging and letterhead system—including boxes, bags, business cards, letterhead, consumer brochures, and bottle labels. A banner used in the store decorations employs the same design as the labels.

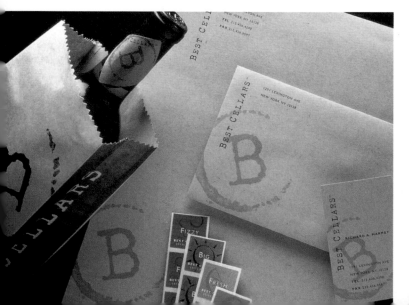

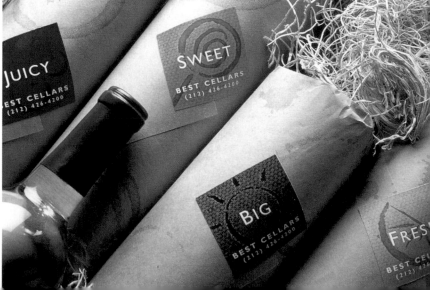

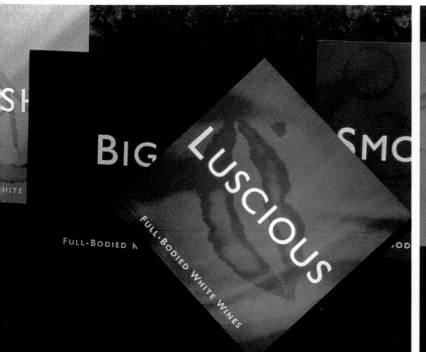

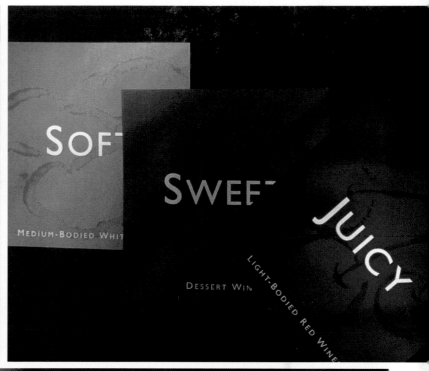

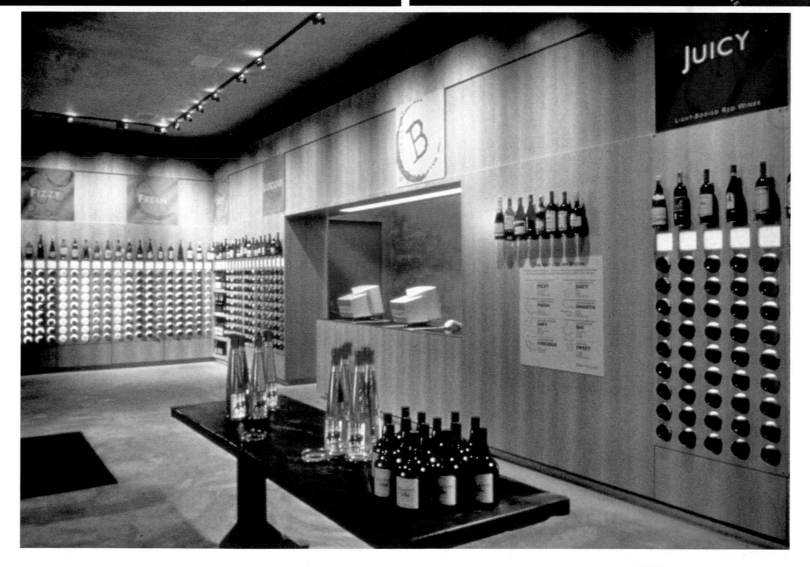

THE TIDES CORPORATE IDENTITY

DESIGN FIRM: David Carter Design Associates
LOCATION: Dallas, TX
CLIENT: The Tides
LOCATION: Miami Beach, FL
ART DIRECTOR: Lori B. Wilson
DESIGNER: Kathy Baronet
DISTRIBUTION: 300 pcs., In-house

*Corrugated paper was used as the primary
decorative element in this identity program,
which was printed entirely in two colors on
two complementary hues of text stock. Hand
assembled and bound with screw posts, the
easily replaced pages kept costs to a minimum.*

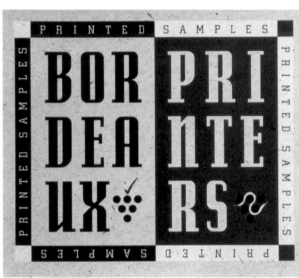

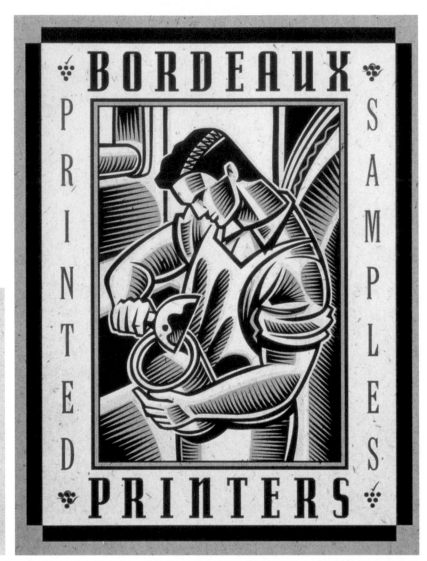

BORDEAUX WRAPPING PAPER & HANG TAGS

DESIGN FIRM: Mires Design
LOCATION: San Diego, CA
CLIENT: Bordeaux Printers
LOCATION: San Diego, CA
ART DIRECTOR: José A. Serrano
DESIGNERS: José A. Serrano, Miguel Perez
ILLUSTRATOR: Tracy Sabin
DISTRIBUTION: 1,000 pcs., Local

Using a simple palette of three PMS colors, strong imagery, and a striking concept, this studio's solution took advantage of the printing house's name and its similarity to the name of a popular type of wine. The entire project was meant to promote the printer's high-end capabilities. Labels and hang tags are used as part of the quality-assurance program; they are signed by both the production staff and the sales representatives to assure clients that the printed samples had been carefully inspected. The entire package was combined with a bottle of Bordeaux wine and sent not only to prospective clients but to existing ones as well as an after-job premium.

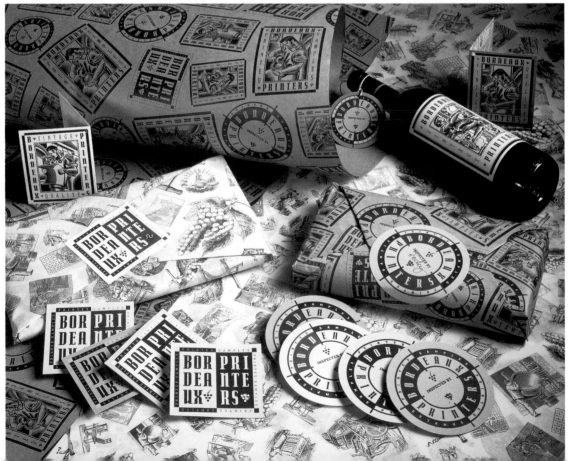

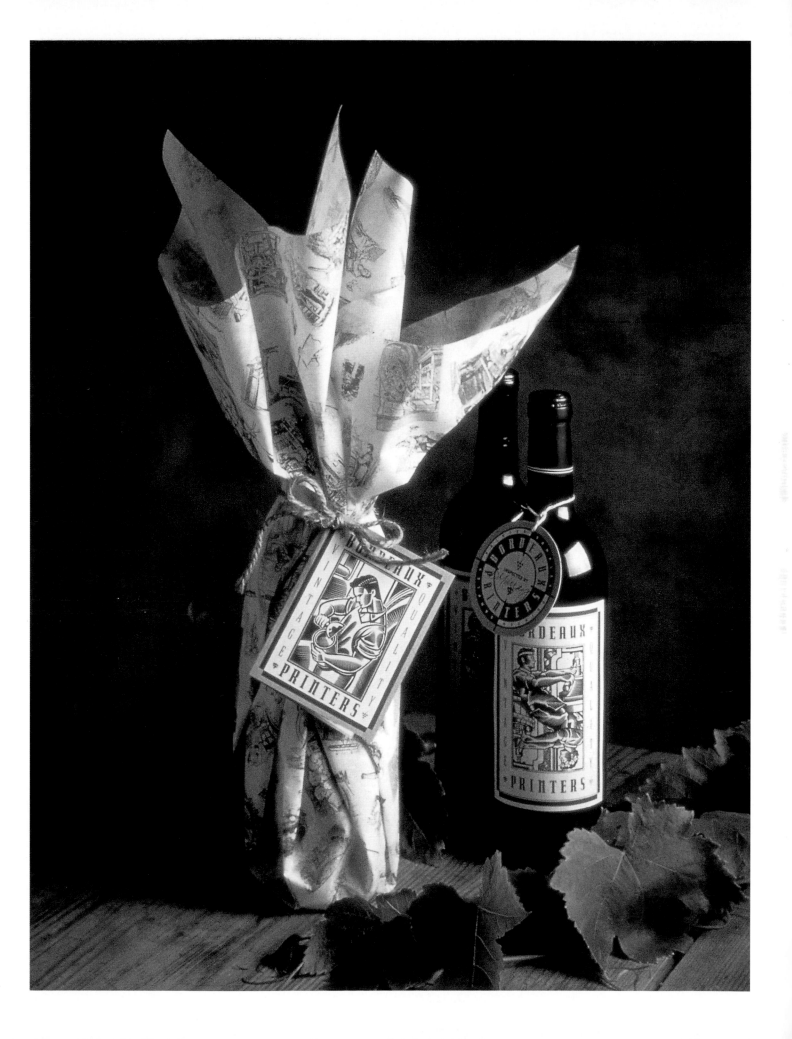

FASHION WEEK IDENTITY

DESIGN FIRM: Misha Design Studio
LOCATION: Boston, MA
CLIENT: Fashion Week
LOCATION: Boston, MA
ART DIRECTOR: Michael Lenn
DESIGNER: Michael Lenn
ILLUSTRATOR: Michael Lenn
DISTRIBUTION: Regional

This client wanted a one-color event logo that could be used in newspaper ads as well as promotional materials without added color expense. The solution expresses the linear feeling of traditional fashion drawings.

RUSSIAN-AMERICAN MUSIC ASSOCIATION IDENTITY

DESIGN FIRM: Misha Design Studio
LOCATION: Boston, MA
CLIENT: Russian-American Music Association
LOCATION: Boston, MA
ART DIRECTOR: Michael Lenn
DESIGNER: Michael Lenn
ILLUSTRATOR: Michael Lenn
DISTRIBUTION: International

This client required a cost-conscious solution to its corporate-identity dilemma. The one-color logo was purposefully designed so it could be easily reproduced in newspaper advertising, brochures, letterhead, and other promotional materials in a variety of sizes.

DENNIS MARCHANT EXCAVATING LOGO

DESIGN FIRM: The Weller Institute for the Cure of Design
LOCATION: Oakley, UT
CLIENT: Dennis Marchant Excavating
LOCATION: Peoa, UT
ART DIRECTORS: Don Weller, Cha Cha Weller
DESIGNER: Don Weller
ILLUSTRATOR: Don Weller
DISTRIBUTION: Regional

Executed in exchange for the client's services, this logo's strength is derived from its strong central image and type selection. The identity stands up without additional color treatment, making it a cost-effective solution that can be used on business cards, telephone directory ads, and newspaper classifieds.

RED ANT RECORDS IDENTITY

DESIGN FIRM: Mike Salisbury Communications
LOCATION: Torrance, CA
CLIENT: Red Ant Records
LOCATION: Beverly Hills, CA
ART DIRECTOR: Mike Salisbury
DESIGNER: Leslie Carbaga
ILLUSTRATOR: Leslie Carbaga
DISTRIBUTION: International

Using only three PMS colors for this identity program, the designer created this logo for a high-profile record company looking for high-impact on a low budget.

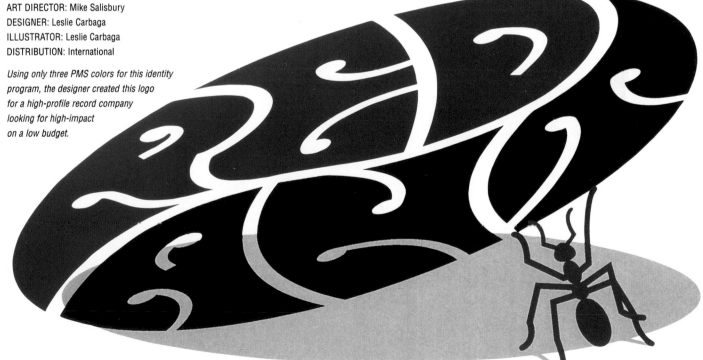

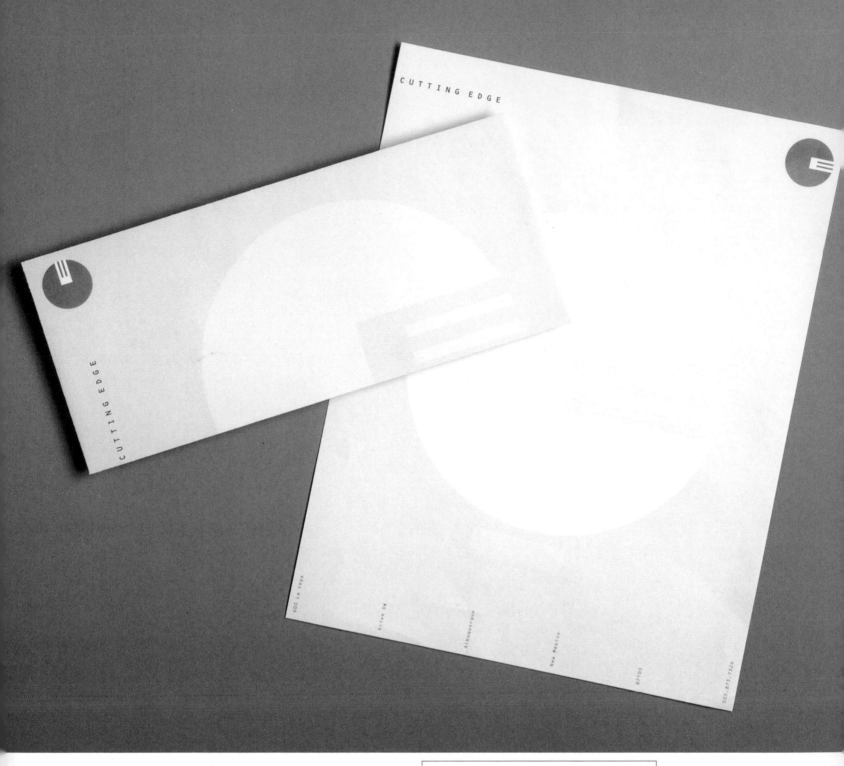

CUTTING EDGE

CUTTING EDGE

DESIGN FIRM: Vaughn/Wedeen Creative
LOCATION: Albuquerque, NM
CLIENT: Cutting Edge
LOCATION: Albuquerque, NM
ART DIRECTOR: Rick Vaughn
DESIGNER: Rick Vaughn
DISTRIBUTION: 1,500 pcs., National

*Employing only black and one PMS ink,
depth and color were achieved by using
screens of tints on both the envelope
and the letterhead.*

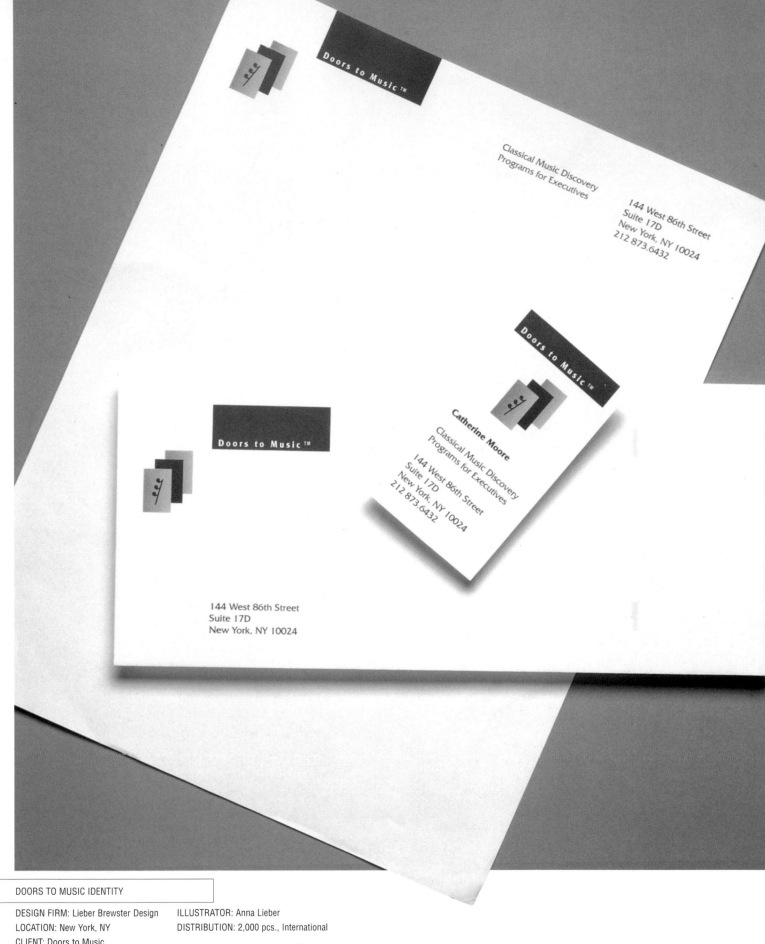

DOORS TO MUSIC IDENTITY

DESIGN FIRM: Lieber Brewster Design
LOCATION: New York, NY
CLIENT: Doors to Music
LOCATION: New York, NY
ART DIRECTOR: Anna Lieber
DESIGNER: Anna Lieber

ILLUSTRATOR: Anna Lieber
DISTRIBUTION: 2,000 pcs., International

Keeping to a two-color palette, this logo was illustrated by using simple shapes, color blends, and a typographic dingbat.

multimedia & websites

he Web has introduced a new, highly economical marketing vehicle that eradicates the high expense of printing and postage. And designers are discovering even more cost-effective ways to produce their clients' sites. Web problem-solving resembles broadcast design and animation. Clean, strong images and type treatments paired with simple navigation and minimal programming embellishment can achieve striking results that don't require years of programming expertise or a stack of peripheral software on the viewer's end.

But unlike television commercials or CD-based multimedia (not to mention print media), Websites can be inexpensively updated daily, if needed, without a high financial penalty. Improved HTML and Java scripting over the past year, the growing availability of public domain and rights-free photography and illustrations, and the expanding imaginations of both Web and multimedia designers in this new environment are changing the way both studios and clients promote their presence on the Web.

Money is like a sixth sense, and you can't make use of the other five without it.

—W. Somerset Maugham

ROBERT SONDGROTH PHOTOGRAPHY

DESIGN FIRM: Canary Studios
LOCATION: Oakland, CA
CLIENT: Robert Sondgroth Photography
LOCATION: Oakland, CA
ART DIRECTOR: Ken Roberts
DESIGNER: Ken Roberts
PHOTOGRAPHER: Robert Sondgroth
ANIMATOR: Ken Roberts
DISTRIBUTION: 250 disks, Local

The photographer needed a self-promotion piece that could be easily changed and would show his work in a format other than print.

INFO

SELECT ONE

QUIT

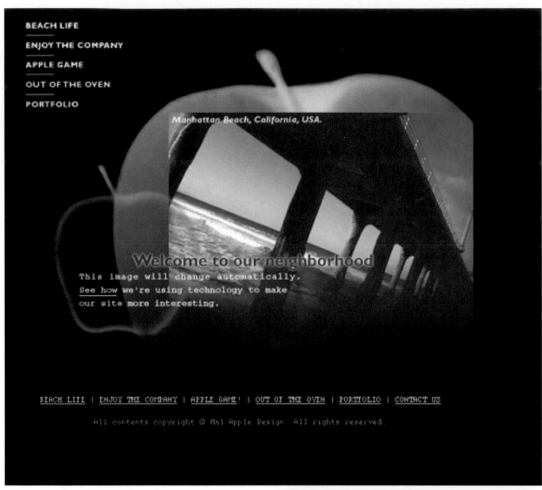

HAL APPLE DESIGN

DESIGN FIRM: Halapple Design & Communications, Inc.
LOCATION: Manhattan Beach, CA
CLIENT: Halapple Design & Communications, Inc.
LOCATION: Manhattan Beach, CA
ART DIRECTORS: Hal Apple, Alan Otto
DESIGNERS: Alan Otto, Rebecca Cwiak, Jason Hashmi
ILLUSTRATORS: Jason Ware, Hal Apple, Doug Cwiak
WEB DESIGNERS: Rebecca Cwiak, Hal Apple
PROGRAMMER: Rebecca Cwiak
DISTRIBUTION: International

*The design team went through a five-month learning
process so they could create every facet of their Website
in-house, including illustrative materials and programming.*

T I P

The Web is ultimate cheap media, but it's only effective if a Website is promoted and maintained properly. Build META heads into every page of the site. Promote it to as many search engines as you can. Submit it for awards and other recognition. Then update regularly if you want repeat visitors.

UPTIME COMPUTER SERVICES, INC. WEBSITE
(WWW.UPTIMEWEB.COM/UPTIME/WEST)

DESIGN FIRM: Grafik Communications, Ltd.
LOCATION: Alexandria, VA
CLIENT: Uptime Computer Services, Inc.
LOCATION: Alexandria, VA
ART DIRECTOR: Joe Barsin
DESIGNER: Joe Barsin
ILLUSTRATOR: Joe Barsin
WEB DESIGNER: Joe Barsin
PROGRAMMER: Joe Barsin
DISTRIBUTION: International

This Website was executed pro bono. The designer was also the illustrator and programmer.

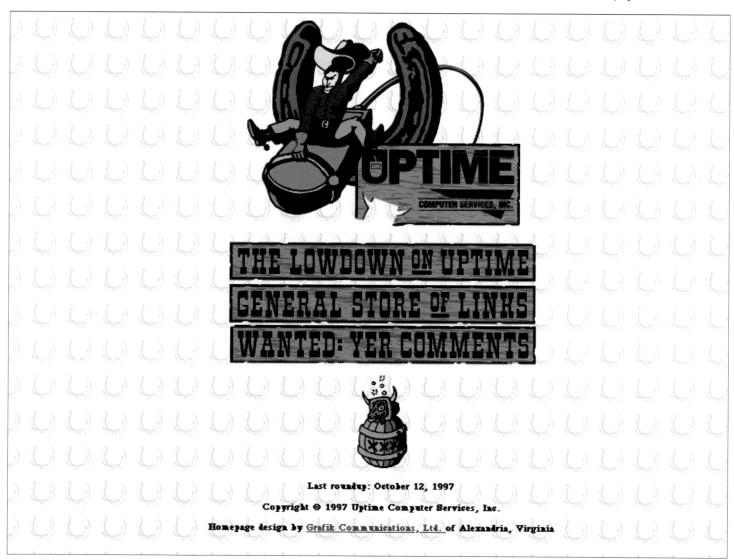

UPTIME
COMPUTER SERVICES, INC.

THE LOWDOWN ON UPTIME

GENERAL STORE OF LINKS

WANTED: YER COMMENTS

Last roundup: October 12, 1997

Copyright © 1997 Uptime Computer Services, Inc.

Homepage design by Grafik Communications, Ltd. of Alexandria, Virginia

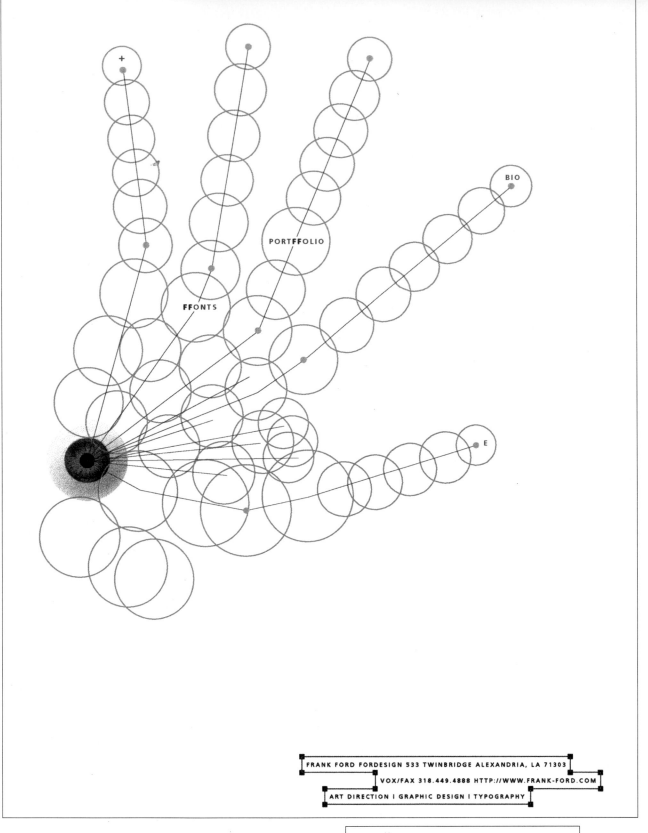

FRANK FORD FORDESIGN 533 TWINBRIDGE ALEXANDRIA, LA 71303

VOX/FAX 318.449.4888 HTTP://WWW.FRANK-FORD.COM

ART DIRECTION I GRAPHIC DESIGN I TYPOGRAPHY

FORDESIGN WEBSITE (WWW.FRANK-FORD.COM)

DESIGN FIRM: Fordesign
LOCATION: Alexandria, LA
CLIENT: Fordesign
LOCATION: Alexandria, LA
ART DIRECTOR: Frank Ford
DESIGNER: Frank Ford
ILLUSTRATOR: Frank Ford
WEB DESIGNER: Frank Ford
PROGRAMMER: Frank Ford
DISTRIBUTION: International

This Website was designed to keep links to a minimum for easier programming and navigation. Everything is keyed to a single image map to keep the opening image and the overall site clean.

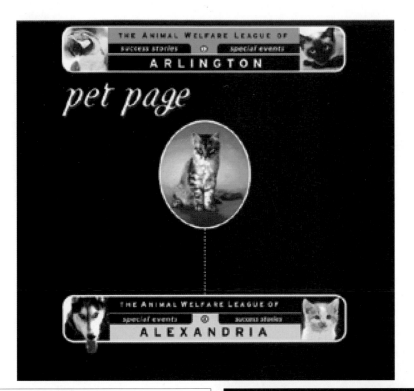

PET PAGE (WWW.PETPAGE.ORG)

DESIGN FIRM: Grafik Communications, Ltd.
LOCATION: Alexandria, VA
CLIENT: Arlington & Alexandria Animal Hospitals
LOCATION: Alexandria, VA
CREATIVE DIRECTOR: Judy Kirpich
ART DIRECTOR: Johnny Vitorovich
DESIGNER: Johnny Vitorovich
PHOTOGRAPHERS: Pam Soorenko, Pat Crowe,
Oi Jakraat Veerasaran, Debbie Fox, Johnny Vitorovich,
Susan Osborn, and various stock
WEB DESIGNERS: Johny Vitorovich, Judy Kirpich
PROGRAMMERS: Johny Vitorovich, Judy Kirpich
DISTRIBUTION: International

*The design team contacted a group of photographers
they frequently contracted with to see if they would
be willing to donate existing images and shoot
original art for this site. The response was over-
whelming. Many of the photographers had worked
with animals in the past and were more than willing
to work pro bono. The balance of the project was
shot in-house or acquired from a stock CD the
studio already had purchased.*

Smaller Creatures

Insects

Species from North, Central and South America including Grasshoppers & Katydids, Butterflies & Moths, Beetles, Mantids etc.

Frogs

A large collection of Frogs and Toads including Arrow-poison frogs, Treefrogs, tropical Toads etc.

Other Reptiles & Amphibians

Dozens of species including Caiman, Snakes, Lizards, Salamanders etc.

Amazonia

Images of village life, industry, ecology, rainforest destruction and conservation.

Working with the Rainforest Conservation Fund, Greg Neise has traveled to some of the most remote forests on earth.

His views of the forest, the people living in the forest and the creatures of the rainforest are compelling and (photo editors take note!) accurately labeled.

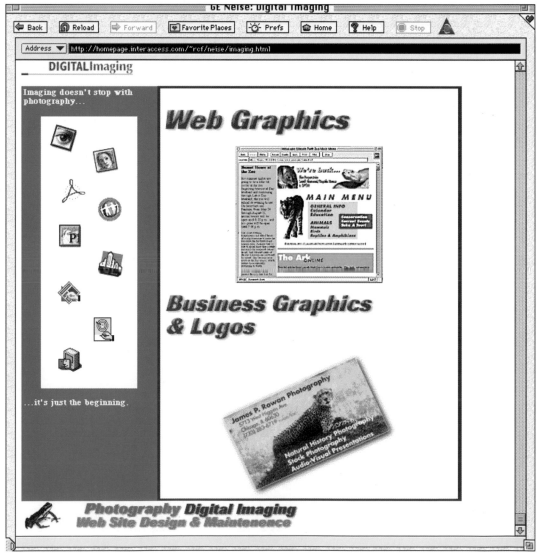

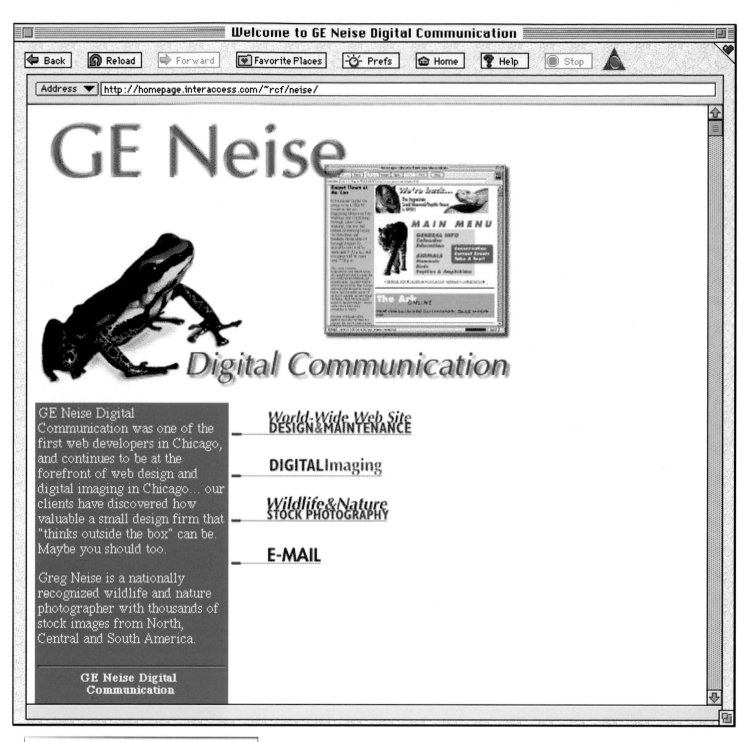

Back Reload Forward Favorite Places Prefs Home Help Stop

Address ▼ http://homepage.interaccess.com/~rcf/neise/

GE Neise
Digital Communication

GE Neise Digital Communication was one of the first web developers in Chicago, and continues to be at the forefront of web design and digital imaging in Chicago... our clients have discovered how valuable a small design firm that "thinks outside the box" can be. Maybe you should too.

Greg Neise is a nationally recognized wildlife and nature photographer with thousands of stock images from North, Central and South America.

GE Neise Digital Communication

World-Wide Web Site **DESIGN&MAINTENANCE**

DIGITALImaging

Wildlife&Nature **STOCK PHOTOGRAPHY**

E-MAIL

HOMEPAGE.INTERACCESS.COM/~RCF/NEISE

DESIGN FIRM: GE Neise Digital Communication
LOCATION: Chicago, IL
CLIENT: GE Neise Digital Communication
LOCATION: Chicago, IL
ART DIRECTOR: GE Neise
DESIGNER: GE Neise
ILLUSTRATOR: GE Neise
PHOTOGRAPHER: GE Neise
WEB DESIGNER: GE Neise
DISTRIBUTION: International

Providing a wide range of services for his clients, this photographer/designer's personal presence displays a massive stock photography archive and Website development and management, as well as digital illustration. There are no bells or whistles used on this site, just a strong layout and loads of continuity. Because the information is available on-call throughout the world, a minor fortune was saved on mailing lists, postage, and four-color print marketing campaigns throughout the year.

WWW.LPZOO.COM

DESIGN FIRM: GE Neise Digital Communication
LOCATION: Chicago, IL
CLIENT: Lincoln Park Zoo
LOCATION: Chicago, IL
ART DIRECTOR: GE Neise
DESIGNER: GE Neise
ILLUSTRATOR: GE Neise
PHOTOGRAPHER: GE Neise
WEB DESIGNER: GE Neise
DISTRIBUTION: International

Packed with over 400 downloadable files, the Lincoln Park Zoo's site was designed to be quick-loading and requires no special plug-ins to be added to the viewer's software. A vibrant color palette is used throughout to break up the remarkable amount of highly readable text. All of the photographs and illustrations were culled from either the client's or the designer's massive archives. Even the "Lion cam" live robotic camera requires no additional software to use and allows visitors to view continuously updated portions of one of the zoo's most popular exhibit areas.

Lincoln Park Zoo
BIRDS

Species Data Sheets

Click on any of the links at right to access that species data sheet.

At right is a listing, in alphabetical order by common name, of the birds at Lincoln Park Zoo.

LPZ's birds are housed at the:

- Robert R. McCormick Bird House
- Regenstein Bird of Prey Exhibit
- Penguin and Seabird House
- Pritzker Children's Zoo.

Click on the letters below to jump to that part of the bird list.

| A-H | I-O | P-S | T-Z |

Common Name	Scientific Name
African Jacana	Actophilornis africana
African Pygmy Goose	Nettapus auritus
American Avocet	Recurvirostra americana
American Kestrel/Sparrowhawk	Falco sparverius (no subsp)
Bald Eagle	Haliaeetus leucocephalus (no subsp)
Bali/Rothschild's Mynah	Leucopsar rothschildi
Barn Owl	Tyto alba
Beautiful Fruit Dove	Ptilinopus pulchellus
Black-crested Bulbul	Pycnonotus melanicterus
Black-winged Stilt	Himantopus himantopus (no subsp)
Blue-crowned Parrot	Loriculus galgulus
Blyth's Hornbill	Aceros plicatus
Cape Thick-knee	Burhinus capensis (unk subsp)
Chestnut Munia	Lonchura malacca (no subsp)
Chinstrap Penguin	Pygoscelis antarctica
Cinereous Vulture	Aegypius monachus
Common Barn Owl	Tyto alba (no subsp)
Common Murre	Uria aalge
Common Puffin	Fratercula arctica
Common Screech Owl	Otus asio
Crested Wood Partridge	Rollulus roulroul
Crimson-backed Tanager	Ramphocelus dimidiatus

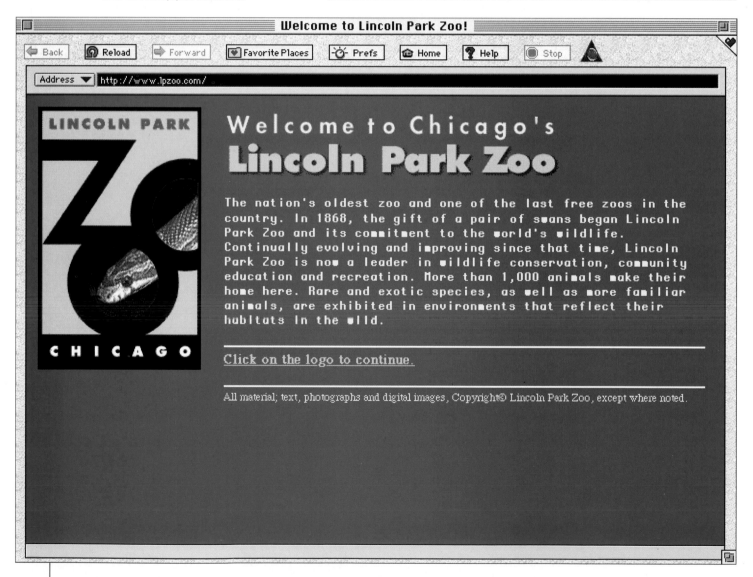

Welcome to Lincoln Park Zoo!

Back | Reload | Forward | Favorite Places | Prefs | Home | Help | Stop

Address ▼ http://www.lpzoo.com/

LINCOLN PARK
ZOO
CHICAGO

Welcome to Chicago's
Lincoln Park Zoo

The nation's oldest zoo and one of the last free zoos in the country. In 1868, the gift of a pair of swans began Lincoln Park Zoo and its commitment to the world's wildlife. Continually evolving and improving since that time, Lincoln Park Zoo is now a leader in wildlife conservation, community education and recreation. More than 1,000 animals make their home here. Rare and exotic species, as well as more familiar animals, are exhibited in environments that reflect their habitats in the wild.

Click on the logo to continue.

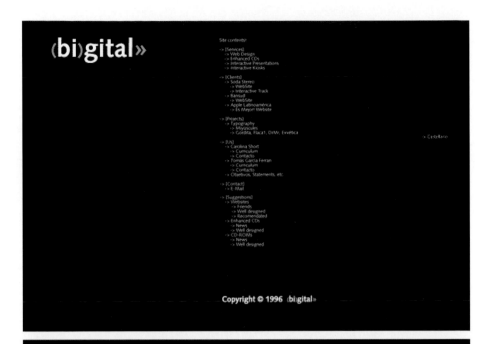

(bi)gital»

BIGITAL.COM

DESIGN FIRM: Bigital
LOCATION: Buenos Aires, RA, Argentina
CLIENT: Bigital
LOCATION: Buenos Aires, RA, Argentina
ART DIRECTORS: Tomás Garcia Ferrari, Carolina Short
DESIGNERS: Tomás Garcia Ferrari, Carolina Short
WEB DESIGNERS: Tomás Garcia Ferrari, Carolina Short
PROGRAMMERS: Tomás Garcia Ferrari, Carolina Short
DISTRIBUTION: International

Using a Power Macintosh 8500, a bunch of software, a dial-up connection to the Internet, and server space rented for a few dollars per month, the studio created this internationally distributed capabilities promotion. Typographic treatment, color selection, and layout were the only elements combined with intuitive design savvy to create this striking project.

Prairie Packaging

Durability • Style • Convenience

Company Information

Where is Prairie Packaging?
Who is Prairie Packaging?

Products

A comprehensive directory of Prairie Packaging's product lines.

E-Mail Directory

A directory of E-mail addresses at Prairie Packaging.

Links to other resources

Other food-service related web sites.

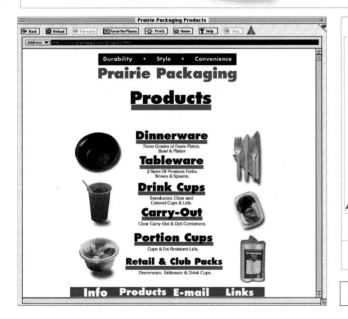

Prairie Packaging Products

Back | Reload | Forward | Favorite Places | Prefs | Home | Help | Stop

Address: http://www.prairiepack.com/products.html

Durability • Style • Convenience

Prairie Packaging

Products

Dinnerware
Three Grades Of Foam Plates, Bowl & Platter

Tableware
3 Sizes Of Premium Forks, Knives & Spoons.

Drink Cups
Translucent, Clear and Colored Cups & Lids.

Carry-Out
Clear Carry-Out & Deli Containers.

Portion Cups
Cups & Fat Resistant Lids.

Retail & Club Packs
Dinnerware, Tableware & Drink Cups.

Info Products E-mail Links

FIELDWARE Mediumweight Cutlery

	STOCK NUMBER	DESCRIPTION	LENGTH	CASE / PACK	CUBE
	FW-MW	FORK	5-13/16"	1000 BULK	1.27
	FW-KW	KNIFE	6-1/14"	1000 BULK	.65
	FW-SW	TEASPOON	5-9/16"	1000 BULK	1.04
	FW-SSW	SOUP SPOON	5-5/16"	1000 BULK	.97

- Break-Resistant Polypropylene
- Economical
- Practical
- Cross-Ribbed With Chamfered Handles For Strength

Available only in white

Info Products E-mail Links

Prairieware, Meadoware and Fieldware are registered trademarks of Prairie Packaging, Inc.

WWW.PRAIRIEPACK.COM

DESIGN FIRM: GE Neise Digital Communication
LOCATION: Chicago, IL
CLIENT: Prairie Packaging, Inc.
LOCATION: Chicago, IL
ART DIRECTOR: GE Neise
DESIGNER: GE Neise
ILLUSTRATOR: GE Neise
PHOTOGRAPHER: GE Neise
WEB DESIGNER: GE Neise
DISTRIBUTION: International

The look of the product and an assurance of durability and style were the messages the designer needed to convey in this very clean yet striking Website. The studio shot all of the photography and developed the site in-house, so no additional costs were billed to the client. The straight-and-simple design approach didn't require any additional studio time to produce and doesn't add hidden charges for complicated updates.

SOUTH LOOP DEVELOPERS

| Bicycle Station Lofts | Tandem Lofts | Builder's Story & Concept | Area Map | Contact Us |

The South Loop neighborhood is Chicago's most exciting new neighborhood. Just minutes from the Prairie Avenue Historic District, South Loop Developers is in the heart of an engaging new residential area.

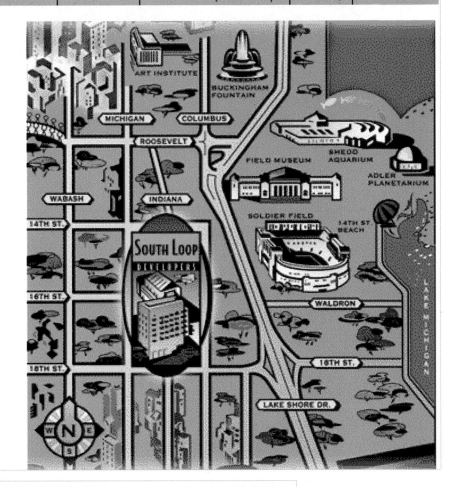

WWW.SOUTH-LOOP.COM

DESIGN FIRM: GE Neise Digital Communication
LOCATION: Chicago, IL
CLIENT: South Loop Developers
LOCATION: Chicago, IL
ART DIRECTOR: GE Neise
DESIGNER: GE Neise
ILLUSTRATOR: GE Neise
PHOTOGRAPHER: GE Neise
WEB DESIGNER: GE Neise
DISTRIBUTION: International

Used as a marketing tool for a real estate development on Chicago's Near South Side, a strong color palette and crisp layout convey the Website's essential messages rather than relying on Java scripting, animated GIFs, or other specialized techniques.

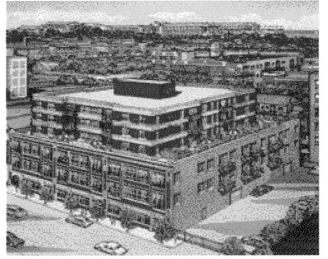

Information about Tandem Lofts, including floor plans will be here shortly...please check back soon!!

COMFORT Y MÚSICA PARA VOLAR

DESIGN FIRM: Bigital
LOCATION: Buenos Aires, RA, Argentina
CLIENT: Soda Stereo (Charly Alberti, Gustavo Cerati, Zeta Boslo)
LOCATION: Buenos Aires, RA, Argentina
ART DIRECTORS: Tomás Garcia Ferrari, Carolina Short, Soda Stereo
DESIGNERS: Tomás Garcia Ferrari, Carolina Short, Gabriele Malerba
(CD cover)
PROGRAMMERS: Tomás Garcia Ferrari, Carolina Short, André Mayo
(CD mastering)
DISTRIBUTION: International

*This project was economically developed using a VHS-format video
from MTV that features both the Soda Stereo Unplugged concert
and scenes from backstage. (Additional still photographs were shot
by the designers.) The studio digitized the videos on a 8500/150
and a 6100/60 Power Macintosh, using the Apple Media Tool, which
compiles data for both PC- and Mac-based software without the
need to reformat. Besides sponsoring the band itself, Apple provided
the studio with this valuable piece of software.*

TESA Total Environmental Services Alliance

**TESA is committed to excellence and growth
TESA's primary objective is to build
long-term relationships with its clients.**

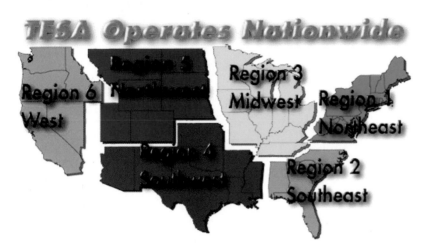

TESA Operates Nationwide

Region 6 West

Region 3 Midwest

Region 1 Northeast

Region 2 Southeast

- **TESA is...**
- **TESA Process**
- **TESA Profile**
- **Member Capabilities**
- **Member Clients**
- **Teams For Special Projects**
- **TESA Core Values**
- **How TESA Works**
- **How to Join TESA**
- **How to Contact TESA**

TESA Total Environmental Services Alliance

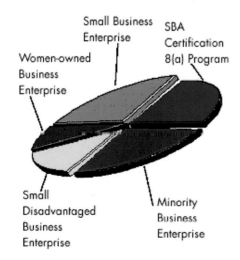

Small Business Enterprise

SBA Certification 8(a) Program

Women-owned Business Enterprise

Small Disadvantaged Business Enterprise

Minority Business Enterprise

WWW.TESAINC.COM

DESIGN FIRM: GE Neise Digital Communication
LOCATION: Chicago, IL
CLIENT: Tesa, Inc.
LOCATION: Chicago, IL
ART DIRECTOR: GE Neise
DESIGNER: GE Neise
ILLUSTRATOR: GE Neise
WEB DESIGNER: GE Neise
PROGRAMMER: GE Neise
DISTRIBUTION: International

*The capabilities of a conglomerate can be difficult
to portray graphically. But using simple, colorful
elements such as an appealing logo, bright pie
charts, and an easy-to-read layout cost very little
to create a Web presence.*

DARKWING.UOREGON.EDU/~KWIANT

DESIGN FIRM: G
LOCATION: Eugene, OR
CLIENT: Substance Abuse Prevention Program
LOCATION: Eugene, OR
ART DIRECTOR: Gary Leung
DESIGNER: Gary Leung
ILLUSTRATOR: Gary Leung
PHOTOGRAPHERS: Miki Mace, Gary Leung,
Nuri Kilani
WEB DESIGNER: Gary Leung
PROGRAMMER: Gary Leung
DISTRIBUTION: International

*Using a neutral background to offset the lively
photographs and repetitive animated GIF found
on every page, the designer created a comfortable-
to-read and consistent presence for this
nonprofit organization.*

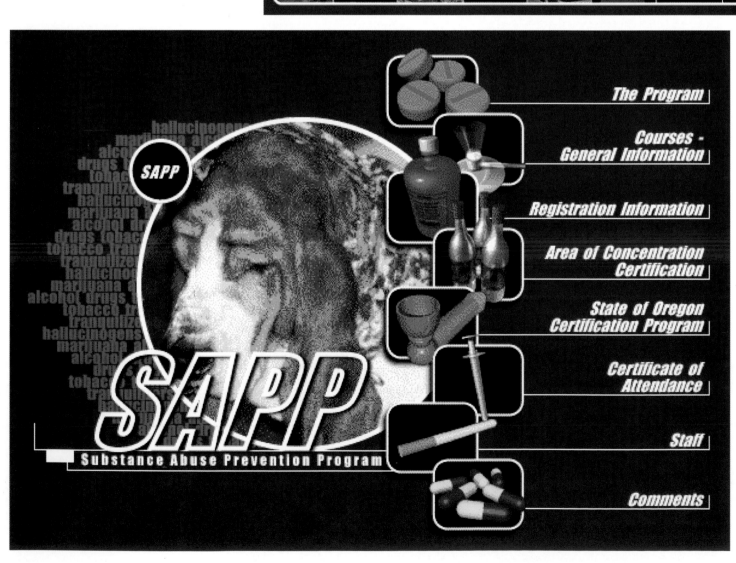

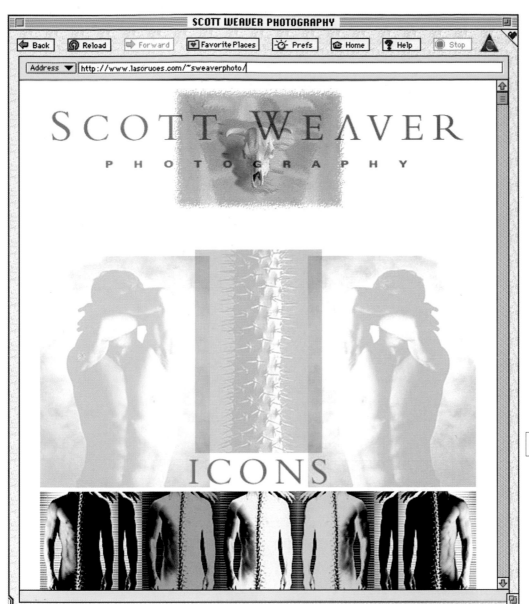

WWW.LASCRUCES.COM/~SWEAVERPHOTO

DESIGN FIRM: Scott Weaver Photodesign
LOCATION: Las Cruces, NM
CLIENT: Scott Weaver Photodesign
LOCATION: Las Cruces, NM
ART DIRECTOR: Scott Weaver
DESIGNER: Scott Weaver
ILLUSTRATOR: Scott Weaver
PHOTOGRAPHER: Scott Weaver
WEB DESIGNER: Scott Weaver
DISTRIBUTION: International

In late 1995, the photographer/designer of the online portfolio knew very little about the Web and Adobe Photoshop. He taught himself and executed all of his own programming and design to drastically reduce the overall cost of distributing a marketing promotion throughout the world.

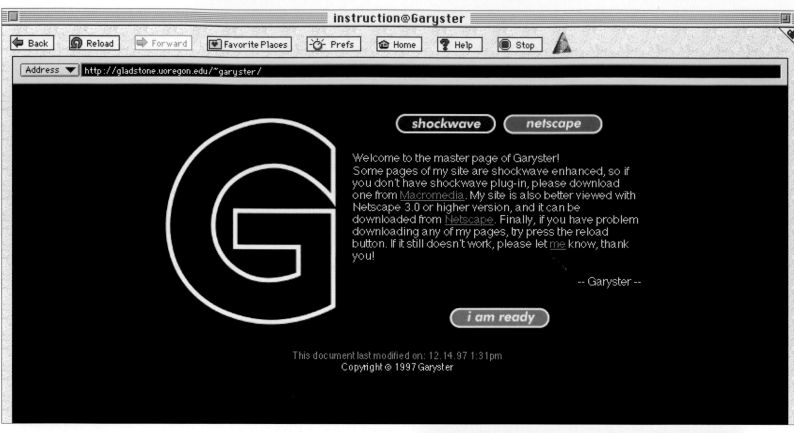

Back | Reload | Forward | Favorite Places | Prefs | Home | Help | Stop

Address ▼ http://gladstone.uoregon.edu/~garyster/

shockwave netscape

Welcome to the master page of Garyster!
Some pages of my site are shockwave enhanced, so if
you don't have shockwave plug-in, please download
one from Macromedia. My site is also better viewed with
Netscape 3.0 or higher version, and it can be
downloaded from Netscape. Finally, if you have problem
downloading any of my pages, try press the reload
button. If it still doesn't work, please let me know, thank
you!

-- Garyster --

i am ready

This document last modified on: 12.14.97 1:31pm
Copyright © 1997 Garyster

GLADSTONE.UOREGON.EDU/~GARYSTER

DESIGN FIRM: G
LOCATION: Eugene, OR
CLIENT: G
LOCATION: Eugene, OR
ART DIRECTOR: Gary Leung
DESIGNER: Gary Leung
ILLUSTRATOR: Gary Leung
PHOTOGRAPHER: Gary Leung
WEB DESIGNER: Gary Leung
PROGRAMMER: Gary Leung
DISTRIBUTION: International

*The designer applied a clean and simple
approach to the design and navigation
of his own Web presence, which didn't
have any additional or hidden costs for
photography or illustration.*

T I P

**Now that inexpensive, powerful computers are available to all
designers, slick imagery that looks computer generated is common.
Imagery that appears to be hand-made now stands out in the sea
of imagery we face every day.**

Environmental Awareness Program

Picture of Crater Lake is taken by Bernd Mohr

Coordinator: Mel Jackson

Listing of Past and Current Workshops

Bernd Mohr's Oregon Picture Album

An Interactive Version of This Site

Eugene Programs

Continuation Center Home Page

The **Environmental Awareness Program** crosses several disciplines to provide a well-rounded, field-based learning opportunity designed to enhance participants' sensitivity to our environment. This program relies on first hand experience at field-lab sites including the Oregon coast, rivers, mountains, and deserts. Excursions to sites such as scenic Crater Lake help to reinforce material covered in the classroom. Most workshops last three days and usually include the weekend in order to accomodate the schedules of both full-time students and working professionals in the Eugene/Springfield community.

Oregon has some of the most exciting and varied field-labs in the country, from the smallest algae, lichens and ferns, to majestic mountains, lakes and rivers. The opportunity for environmental study is superb. The broad diversity and close proximity of resources such as the Pacific Ocean, volcanic Cascades, the high desert and Crater Lake make it possible to use the resources of Oregon as field-labs, to allow students personal contact with the environment, and to create an awareness, consciousness and sensitivity to that environment.

The **Environmental Awareness Program** gives students a rare opportunity to truly understand the many facets of our region. Students will be close to the things they study: seeing, smelling, hearing and touching in order to gain a wide perspective and a magical appreciation for Oregon.

Through the best information available and on-site, visual and sensory images, we hope to provide a fundamental "frame of reference" for informed decision making. We will examine many sides of environmental issues including advantages and disadvantages of past and current decisions concerning our natural resources. We want to showcase opportunities for recreation and further study, and show the results of human action and activity on specific areas. Our objective is to develop an environmental ethic that assists people in making more informed decisions about the places they live. We continue to explore field-lab areas and add additional information to the curriculum. We are committed to creating workshops that fit students' educational needs.

CENTER.UOREGON.EDU/EUGENE/
ENVAWARE/ENVAWARE.HTML

DESIGN FIRM: G
LOCATION: Eugene, OR
CLIENT: Environmental Awareness Program
LOCATION: Eugene, OR
ART DIRECTOR: Gary Leung
DESIGNER: Gary Leung
ILLUSTRATOR: Gary Leung
PHOTOGRAPHER: Gary Leung
WEB DESIGNER: Gary Leung
PROGRAMMER: Gary Leung
DISTRIBUTION: International

Focusing on Oregon's natural environment, this Website was designed to reflect the area's abundant water and big sky. Because this is a text-heavy site, the color palette was kept light and the supporting images were purposefully selected to be simple and direct. Without any complicated coding, this site was also extremely cost effective.

www.roguemedia.com.hk

rogue media

RAPSHEET
FUNNY PAPERS
SHOOTING GALLERY
MERCTOWN

CREATIVE. DESIGN. MULTIMEDIA.

RogueMedia is a digital media design studio providing high-energy digital media in the forms of multimedia, digital design and electronic art. Based in **Hong Kong**, we are a team of specialists, heralding in the new electronic era to Asia and around the world.

RogueMedia covers the digital spectrum from **graphic design, 3-D rendering, web-programming, multimedia authoring, video editing, electronic illustration, digital imaging, animation development** to **dynamic media consulatation, marketing, sales** and **promotion. RogueMedia** handles your digital media needs from start to finish.

Take a tour of our virtual studio through this web-site and see what we have to offer your future!

RAPSHEET

FUNNY
PAPERS

SHOOTING
GALLERY

MERCTOWN

WWW.ROGUEMEDIA.COM.HK

DESIGN FIRM: Roguemedia
LOCATION: Hong Kong
CLIENT: Roguemedia
LOCATION: Hong Kong
ART DIRECTOR: Casey Lau
DESIGNER: Casey Lau
ILLUSTRATOR: Casey Lau
PHOTOGRAPHER: Casey Lau
WEB DESIGNER: Casey Lau
PROGRAMMER: Casey Lau
DISTRIBUTION: International

This remarkably lively online portfolio was created using freeware and shareware utilities and applications as well as conventional graphic manipulation software. Even the simple but effective animated GIF used on every page was created using freeware. Server rental was the only element costed out on the budget, while time and talent made the project work.

DESIGN FIRM: eman communications design, inc.
LOCATION: West Palm Beach, FL
CLIENT: eman communications design, inc.
LOCATION: West Palm Beach, FL
ART DIRECTOR: Tom Osborne
WEB DESIGNER: Tom Osborne
PROGRAMMER: Eric Norstrom
DISTRIBUTION: International

*Using a series of simple icons that appear through-
out this Website, a recognizable, lively form of
branding takes place immediately as the individual
images flash in a Meta-coded time sequences as
an animated opening screen. The striking color
palette and reinforced imagery carry visitors in high
or low bandwidth through a dense capabilities port-
folio for both the studio and agency portions of the
firm with-out using animated GIFs or Java scripting
that might turn off less techno-oriented viewers.*

eman communications design, inc.

west palm beach, fl || phone 561.835.4758 || fax 561.835.0413 || email ecd@eman.com

capabilities | | webfolio | | advertising | | profile | | contact | | mélange

KRAVIS CENTER

now playing

ROGER WHITTAKER'S "FAMILY CHRISTMAS"

WIN TICKETS

WHAT'S PLAYING

Calendar
Alphabetical List
Show Search
Box Office Info
Order Tickets

EDUCATION & OUTREACH

Teachers
Students
Performances

ABOUT THE CENTER

Helpful Facts & Info
Directions
History
Venues & Facilities
Virtual Tour
Seating Charts
Dreyfoos Hall
GosmanAmphitheatre
Rinker Playhouse
Cohen Pavilion
Café Teatro
People
Officers & Board
Staff
Job Opportunities

show place

THE 1997-98 KRAVIS CENTER SEASON

NEW ADDITION: **James Brown** will be performing in the Dreyfoos Hall on Sunday, January 4th at 8pm

WWW.KRAVIS.ORG

DESIGN FIRM: eman communications design, inc.
LOCATION: West Palm Beach, FL
CLIENT: The Raymond F. Kravis Center for the Performing Arts
LOCATION: West Palm Beach, FL
ART DIRECTOR: Tom Osborne
WEB DESIGNER: Tom Osborne
PROGRAMMER: Eric Norstrom
DISTRIBUTION: International

Developed to suit the broad range of activities that take place at this cultural center for a variety of age groups, this Website uses a clean recipe card tab motif as its branding mechanism. The nonprofit organization's concert schedule, ticket information, history, seating plans, and educational programs are all presented in this site, along with a virtual tour of the center itself.

Helpful Facts & Services

 Directions

 Parking

 Services for Persons with Disabilities

 Tours

 Gift Certificates

Groups

General Information

 Facts & Figures

T E A M O R A C L E

the official dcu-l website

TO VEIW THIS
PAGE, NETSCAPE
4.0 OR ABOVE IS
RECOMMENDED.

JONNY DC

WWW.GEOCITIES.COM/AREA51/3445 (TEAM ORACLE)

DESIGN FIRM: Lev Kalman Design
LOCATION: Stamford, CT
CLIENT: Team Oracle
LOCATION: Stamford, CT
ART DIRECTOR: Lev Kalman
DESIGNER: Lev Kalman
ILLUSTRATOR: Various
WEB DESIGNER: Lev Kalman
DISTRIBUTION: Internationall

*Using the Adobe Photoshop and Illustrator software
that came with the purchase of a new scanner, the
designer produced this Website for little or no money.
The site's animated GIFs and even its server storage
were accomplished by taking advantage of freeware
downloaded off the Internet and the free five MB of
storage space offered by the server company.*

Back | Reload | Forward | Favorite Places | Prefs | Home | Help | Stop

Address ▼ http://www.jhom.com/

Click to open the magazine

Jewish Heritage
Online Magazine

Initiated and sponsored by the Memorial Foundation for Jewish Culture

MFJC

Published by MAXIMA New Media

maxima
NEW MEDIA

Editorial Board: Profs. Daniel Boyarin, Rachel Elior, Moshe Idel, Jacob Milgrom, Dov Noy, Aviezer Ravitzky, Gershon Shaked, Eliezer Schweid, Daniel Sperber.

Academic advisor: Dr. Sam Cooper

WWW.JHOM.COM

DESIGN FIRM: Maxima New Media
LOCATION: Kokhav Yair, Israel
CLIENT: Memorial Foundation for Jewish Culture
LOCATION: New York, NY
ART DIRECTOR: Orit Kariv-Manor
DESIGNER: Simcha Shtull
PROGRAMMER: Itamar Shtull-Trauring
DISTRIBUTION: International

This striking Website's content was provided free of charge in return for a share in revenues and the promotion of each firm's materials. The site's technical infrastructure software was provided free because the firm uses it, taking advantage of available low-cost, high-power software. The site also makes strong use of archival clip art as both a branding mechanism and a navigational device.

Back Reload Forward Favorite Places Prefs Home Help Stop

Address http://www.jhom.com/calendar/calendar.html

The Jewish Calendar / Hayyim Schauss

The calendar in common use throughout the western world is based on the sun. Neither the year nor the months have anything to do with the phases of the moon. The Muslims, on the other hand, reckon both the year and the month according to the phases of the moon. Their year is therefore shorter than the general year by about eleven days. A moon-year has 354 days, and the sun-year 365 days. The Jewish calendar is based on a compromise between the two, and is reckoned according to both the sun and the moon. The months are figured according to the moon (twelve months of 29.5 days each), and the year according to the sun. In order to take up the extra eleven days, a whole month is added to the calendar in leap years. Every second or third year there is a thirteenth month, a second Adar.

The Jewish calendar is a very old one. It has been established a long time and every point and detail has been ironed out. But the history of the calendar, how it evolved and how, in time, it came to be an established fact, is very obscure.

It is to be presumed that in pre-historic times, when Jews were still nomadic shepherd tribes in the wilderness, they reckoned time entirely by the moon, as did all nomadic peoples. But it seems that after they settled in Palestine and began to observe the agriculture seasons, they also began to reckon according to the position of the sun. How the Jews of the period equalized the sun-year and the moon-year we do not know. It is possible that at one time they just added a number of days at the end of each year. In time, however, the method of making every second or third year a leap year was apparently established.

It appears that in the old days Jews figured their calendar - the month, the year, and the festivals - entirely by observation, by testimony offered that the moon had appeared and had been seen. Later, astronomic calculation was instituted in connection with the calendar, but the Jews were not certain of its exactness and still had recourse to witnesses. The authority to hear this testimony and through it to establish the beginning of the month, the intercalation of the calendar, and the dates of the festivals was vested in the Sanhedrin.

When they accepted the report of the witnesses, the New Moon was announced through the lighting of fires on the hill-tops. Later, this method was not considered safe enough, and messengers were sent out to proclaim the date. However, it took time for the messengers of the Sanhedrin in Palestine to reach further lands inhabited by Jews and proclaim there the arrival of the New Moon. It was, therefore, decreed that outside of Palestine, in the lands of the Diaspora, festivals were to be observed for two days instead of one. This added second day was called "the second holiday of the Diaspora." An exception was made in the case of Yom Kippur which, because of the hardship of fasting, could not be prolonged. Rosh Hashanah was also an exception in that it was observed for two days even in

The Life and History of the Jews

Beth Hatefutsoth

The Nahum Goldmann Museum of the Jewish Diaspora

- Multimedia Series -

Timeline

The People

Culture and Literature

Among the Nations

Movements

Eastern Europe

WWW.MAXNM.COM

DESIGN FIRM: Maxima New Media
LOCATION: Kokhav Yair, Israel
CLIENT: Memorial Foundation for Jewish Culture
LOCATION: New York, NY
ART DIRECTOR: Orit Kariv-Manor
DESIGNER: Simcha Shtull
PROGRAMMER: Itamar Shtull-Trauring
DISTRIBUTION: International

Ingenuity, inventiveness, and intuition coupled with standard software tools created this elegant Website. Because the company is in partnership with major publishers and institutions, the site's content was provided free of charge in return for a share in revenues and the promotion of each firm's materials. The site also makes strong use of archival clip art as both a branding mechanism and a navigational device.

Timeline

1666 Messianic fever and disappointment —————————

1648 Chmielnicki massacres ——————————

1580s Council of Four
Lands instituted

1571 Ashkenazi Code
of Jewish Law ————————

1551 Charter of Sigismund Augustus

1538 Anti-Jewish statutes enacted

Eastern Europe

packaging & point of purchase

"Green" is the key word in package and point-of-purchase design. Packaging must have visual appeal on store shelves. But every box eventually becomes trash once it has been purchased and opened. Rather than creating future landfill, designers are leaning toward efficient solutions that employ recycled and recyclable materials paired with strong imagery.

Unlike the costly Kromekote paper and formed plastic predecessors of the 1970s, these containers are relatively environmentally sound. The same solutions are also inexpensive because many of them rely on using in-stock boxes and bags rather than special-order constructions.

ALBA SCHOOL WINERY

DEIGN FIRM: Charney Design
LOCATION: Santa Cruz, CA
CLIENT: Alba School Winery
LOCATION: Scotts Valley, CA
ART DIRECTOR: Carol Inez Charney
DESIGNER: Carol Inez Charney
PHOTOGRAPHER: Susan Friedman
DISTRIBUTION: 300 pcs., Local

Improved digital printing can make a limited-edition press run economical without limiting the designer's solution parameters. These wine-bottle labels were printed directly onto label stock using a Scitex Spontane color proofer.

ALBA SCHOOL
CABERNET SAUVIGNON
1995 CENTRAL COAST
MIS EN BOUTEILLE AU CHATEAU

ALBA SCHOOL
CABERNET SAUVIGNON
1995 CENTRAL COAST
MIS EN BOUTEILLE AU CHATEAU

ALBA SCHOOL
ZINFANDEL
1995 SONOMA
MIS EN BOUTEILLE AU CHATEAU

ALBA SCHOOL
ZINFANDEL
1995 SONOMA
MIS EN BOUTEILLE AU CHATEAU

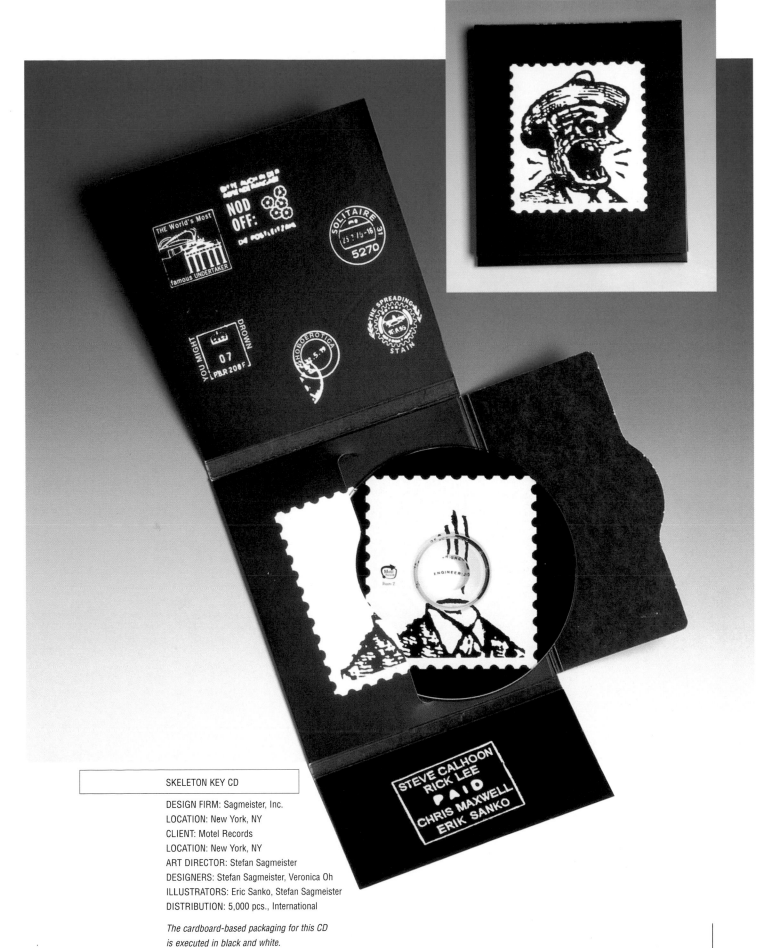

SKELETON KEY CD

DESIGN FIRM: Sagmeister, Inc.
LOCATION: New York, NY
CLIENT: Motel Records
LOCATION: New York, NY
ART DIRECTOR: Stefan Sagmeister
DESIGNERS: Stefan Sagmeister, Veronica Oh
ILLUSTRATORS: Eric Sanko, Stefan Sagmeister
DISTRIBUTION: 5,000 pcs., International

*The cardboard-based packaging for this CD
is executed in black and white.*

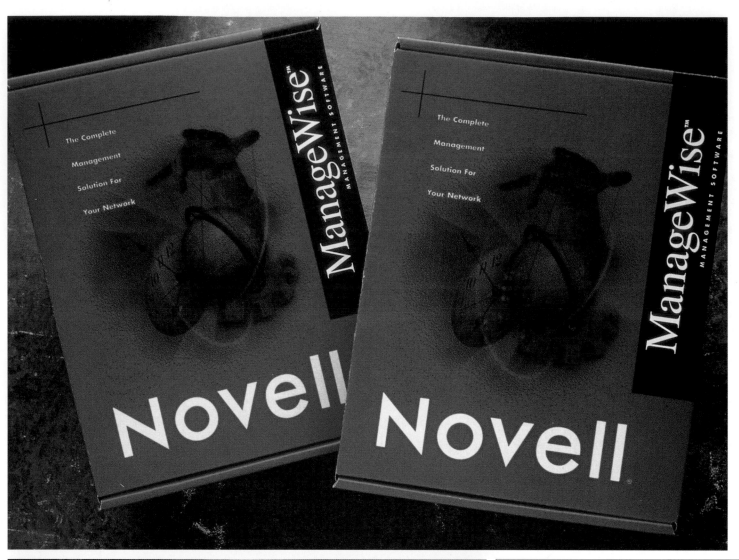

NOVELL PACKAGE SERIES/NOVELL SALES
TOOLS PACKAGE/NOVELL MANAGE WISE PACKAGE

DESIGN FIRM: Hornall Anderson Design Works, Inc.
LOCATION: Seattle, WA
CLIENT: Novell, Inc.
LOCATION: Salt Lake City, UT
ART DIRECTOR: Jack Anderson
DESIGNERS: Jack Anderson, Larry Anderson,
Jana Wilson, Heidi Favour, Debra Hampton, Nicole Bloss
DISTRIBUTION: International

The overriding considerations in any package design solution are its cost-effectiveness and greenness. Product boxes must have visual appeal on store shelves, but every box eventually becomes trash once it has been purchased and opened. Using a striking but limited color palette, these packages are distinctive as display items, taking advantage of the kraft paper stock's natural hue. But unlike its costly Kromekote paper predecessors from the 1970s, these recycled and recyclable boxes are not simply inexpensive packaging alternatives. The paper choice is also an environmentally sound solution.

DESIGN FIRM: Sayles Graphic Design
LOCATION: Des Moines, IA
CLIENT: Gianna Rose
LOCATION: Fountain Valley, CA
ART DIRECTOR: John Sayles
DESIGNER: John Sayles
ILLUSTRATOR: John Sayles
DISTRIBUTION: National

*Minimal packaging is not only an environ-
mentally correct design objective, but it's
also a wise economic choice. The wrapping
for these bath salts is printed in two PMS
colors on a parchment paper stock that is
sealed with a hand-tied ribbon.*

DESIGN FIRM: Hornall Anderson Design Works, Inc.
LOCATION: Seattle, WA
CLIENT: OXO International
LOCATION: New York, NY
ART DIRECTOR: Jack Anderson
DESIGNERS: Jack Anderson, Heidi Favour, David Bates
PHOTOGRAPHER: Tom Collicott
DISTRIBUTION: International

Similar to the Novell package series, this packaging solution uses the natural color of the recycled and recyclable kraft paper stock. The striking design elements also enhance the package's shelf appeal.

TIP

A client photo archive can provide a treasury of free visuals that you can use for illustrating a design project. Don't hesitate to ask your clients what they have available.

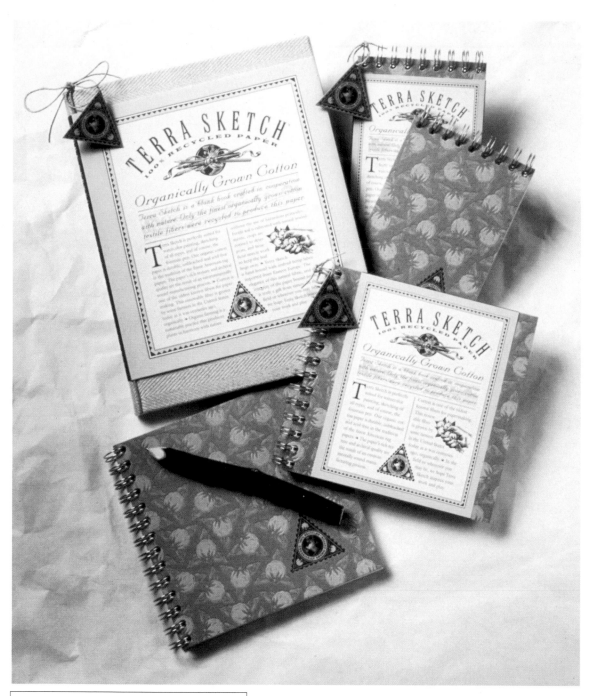

TERRA SKETCH SKETCH BOOKS

DESIGN FIRM: Mires Design
LOCATION: San Diego, CA
CLIENT: Found Stuff Paper Works
LOCATION: San Diego, CA
ART DIRECTOR: José A. Serrano
DESIGNERS: José A. Serrano, Miguel Perez
ILLUSTRATOR: Tracy Sabin
DISTRIBUTION: 2,000 pcs., National

The economies employed in the manufacture of both this project's product and packaging not only saved money, but the environment as well. Leftover organically grown cotton plant matter, rather than expensive wood pulp, serves as the sketch paper's main ingredient. The cover for the large sketch book was woven out of the same plant material in its unbleached state. Besides reducing packaging costs, this concept also branded the paper's content in consumer's minds. Cost savings are also found in the package labels, tags, and smaller sketchbook covers. The entire program was printed on recycled paper in a palette of three PMS colors using soy-based rather than petroleum-based inks.

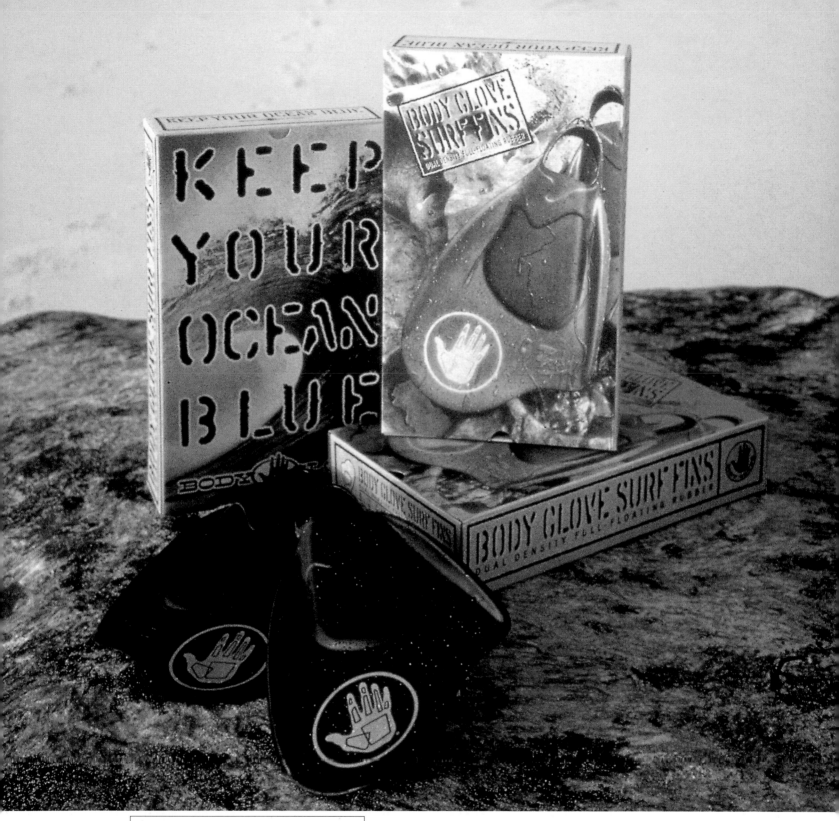

BODY GLOVE SURF FINS

DESIGN FIRM: Mires Design
LOCATION: San Diego, CA
CLIENT: Voit Sports
LOCATION: Carlsbad, CA
ART DIRECTOR: José A. Serrano
DESIGNERS: José A. Serrano, Miguel Perez
PHOTOGRAPHER: Carl Vanderschuit
DISTRIBUTION: National

Corrugated cardboard and a simple two-color palette consisting of black and metallic-silver ink not only drastically reduced the packaging cost of this project the visual ruggedness appeals to its extreme-sports audience.

BISCOTTI DI LASCA

DESIGN FIRM: Lambert Design
LOCATION: Dallas, TX
CLIENT: Nell Baking Company
LOCATION: Kenedy, TX
ART DIRECTOR: Christie Lambert
DESIGNER: Christie Lambert
ILLUSTRATOR: Joy Cathy Price
PHOTOGRAPHER: James Elliott
DISTRIBUTION: 4,000 pcs.
(1,000 of each flavor), National

The client requested an inexpensive container for its new line of biscotti. So the design studio chose an unprinted decorative and protective paper that could be used with printed labels that distinguished each of the four flavors. The paper was cut on a paper cutter rather than die cut, which reduced costs even further on this small-run project.

The secret to **creativity** is knowing how to **hide your sources**.

–Albert Einstein

SPA MENU

DESIGN FIRM: Powell Design
LOCATION: Dallas, TX
CLIENT: Lake Austin Spa Resort
LOCATION: Austin, TX
ART DIRECTORS: Glyn Powell, Dorit Suffness
DESIGNER: Dorit Suffness
PHOTOGRAPHER: Jean Ann Rybee
DISTRIBUTION: 250 pcs., Local

An inviting menu cover and interior must do more than present the restaurant's offerings for the day: it must also convey the style of the cuisine. To economize on the cost of communicating the concepts of fresh, natural, and healthy, the designer combined natural elements like dried flowers along with cost-effective items like tiny full-color iris prints and a two-color cover printed on an uncoated, textured paper stock, which was assembled using an inexpensive heat-lamination process. The replaceable two-color interior menu is bound into the cover with a piece of natural raffia. The original dried-flower art used in the interior layout was photographed on a flatbed scanner.

6

posters & signage

Posters and signs can be expensive to produce and ship, so economic concerns must be seriously considered when developing a design solution. The trend toward self-mailing formats is prevalent among poster designs, as is the use of stock imagery.

Some old-fashioned print and production techniques are also being employed to create powerful yet budget-friendly results. Two-color silk-screen inks impressed on colored paper stock may hearken back to the 1950s and 1960s, but this technique provides a fresh look in a retro-conscious culture. Produced hand-cut color separations using rubylith overlays may not provide the tightest registration on a two-color poster, but with the appropriate imagery the overall effect is both striking and cheap to produce. Hand tinting, adding color to a black-and-white print job with markers or watercolors, can take a minimum of time to produce unique four-color results.

OTHER DISCIPLINES

DESIGN FIRM: J. Graham Hanson Design
LOCATION: New York, NY
CLIENT: AIGA/NY
LOCATION: New York, NY
DESIGNER: J. Graham Hanson
PHOTOGRAPHER: J. Graham Hanson
DISTRIBUTION: 3,000 pcs., Regional

Large-format posters can be expensive to produce and ship, so economic concerns must be seriously considered in every step of a design solution. This self-mailing poster is just one example. Rather than commissioning original photography or purchasing rights to stock images, the designer took a photograph of a chain-link fence at a local construction site and incorporated only a small detail of the image in this strong, two-color design solution.

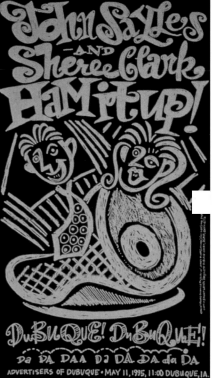

JOHN SAYLES AND SHEREE CLARK:
IN HIGH GEAR/ IN TUNE/ HAM IT UP

DESIGN FIRM: Sayles Graphic Design
LOCATION: Des Moines, IA
CLIENT: Various professional groups
LOCATIONS: Detroit, MI; Cedar Rapids, IA;
and Dubuque, IA
ART DIRECTOR: John Sayles
DESIGNER: John Sayles
ILLUSTRATOR: John Sayles
DISTRIBUTION: 250 pcs., Local

A single color silk-screened onto colored paper stock greatly reduced the overall printing cost of this poster series used to promote presentations by John Sayles and Sheree Clark. Each of the tongue-in-cheek themes and illustrations relate to the location. For instance, In High Gear gives a nod to the automobile industry in Detroit, the location of one of the events.

The Village 1616 Butler West Los Angeles, CA 90025

THE VILLAGE POSTER

DESIGN FIRM: Mike Salisbury Communications
LOCATION: Torrance, CA
CLIENT: The Village
LOCATION: West Los Angeles, CA
ART DIRECTOR: Mike Salisbury
DESIGNER: Mike Salisbury
ILLUSTRATOR: Mike Salisbury
PHOTOGRAPHER: Mike Salisbury
DISTRIBUTION: 5,000 pcs., Regional

*A photomontage of colorful images arranged in
a style similar to one used by fine artist David
Hockney was used as the focal point of this lively
poster. The designer shot the images himself to
reduce the overall costs.*

POWERHOUSE POSTER

DESIGN FIRM: Mike Salisbury Communications
LOCATION: Torrance, CA
CLIENT: Powerhouse Service Bureau
LOCATION: Los Angeles, CA
ART DIRECTOR: Mike Salisbury
DESIGNERS: Dave Willardson Associates
DISTRIBUTION: Regional

Sometimes, the only economically feasible way to produce a design project is to waive the design fee or trade for services with the client. In this case, the design studio traded fees in exchange for services to produce this identity, promotional poster, and outdoor signage for a local service bureau.

DESIGN FIRM: Mike Salisbury Communications
LOCATION: Torrance, CA
CLIENT: Baja Buds
LOCATION: Los Angeles, CA
ART DIRECTOR: Mike Salisbury
DESIGNER: Mary Evelyn McGough
DISTRIBUTION: 100 pcs., Local

Low budget doesn't mean a designer should forget basic design essentials such as relying on strong continuity and branding as the unifying thread of a promotional campaign. Using a bold style, concept, and palette, the designer developed an easy-to-produce campaign that didn't eat up the budget in labor costs.

NOW AT WARNER CENTER AMC 16.

NO LARD.
NO MSG.
NO JUNK.
NO WHERE.

Baja Bud's
DEL NORTE

WINNETKA AND VENTURA

PARK CITY PERFORMANCES PRESENTS

RUMORS
A FARCE BY NEIL SIMON

Directed by Toni Byrd
August 9 - September 21 Thursday thru Saturday Evening at 7:30 pm
Performed by Special Arrangement with Samuel French, Inc.
At the Historic Egyptian Theatre 328 Main Street, Park City

EGYPTIAN
THEATRE

<div style="text-align:center">T I P</div>

Vintage public-domain art is much cheaper than original art or even stock. It may take some digging, but there is a wealth of free images available.

GREATER TUNA

Written by Jaston Williams, Joe Sears, & Ed Howard. Starring: Gary Anderson and Geoff Spade. Directed by Tony Larimer.
June 20 - July 26. Thursday, Friday, & Saturday evenings 7:30 pm (Opening night performance 6/20/97 begins at 8 pm)
Location: Santy Auditorium, Park City Education Center, 1255 Park Ave., Park City, UT
Tickets Available at Main Street Mall and Kimball Arts Center. For reservations call 649-9371
Produced by special arrangement with Samuel French, Inc.

PARK CITY
PERFORMANCES

EGYPTIAN THEATRE POSTERS:
GREATER TUNA/ RUMORS

DESIGN FIRM: The Weller Institute for the Cure of Design
LOCATION: Oakley, UT
CLIENT: Egyptian Theatre
LOCATION: Park City, UT
ART DIRECTOR: Don Weller
DESIGNER: Don Weller
ILLUSTRATOR: Don Weller
DISTRIBUTION: 3,000 pcs., Local

Sometimes old-fashioned methods can yield great results for an economical price. In this case, these two-color and three-color posters were separated by cutting a rubylith overlay of the second and third colors, using black as the base plate. The strong, simple design solutions and illustrations were developed to look good even if the registration was off by a few points and were printed on low-grade coated or uncoated cover stock.

DELEO CLAY TILE

ON THE ROAD TO ANOTHER BEAUTIFUL CLAY TILE ROOF

TEL: 909-674-1578

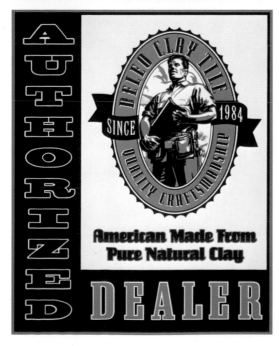

DELEO CLAY TILE POSTERS

DESIGN FIRM: Mires Design
LOCATION: San Diego, CA
CLIENT: Deleo Clay Tile Company
LOCATION: Lake Elsinore, CA
ART DIRECTOR: Jose A. Serrano
DESIGNERS: Phil Fass, José A. Serrano,
Eric Freedman
ILLUSTRATOR: Nancy Stahl
DISTRIBUTION: 1,500 pcs., Regional

An earthy palette of three PMS colors was applied to both the placard and signage for this California-based roof tile company. Using strong images reminiscent of Works Progress Administration posters and advertising from the 1930s, this economical campaign was also transformed into an economical packaging system that continues the branding seen here.

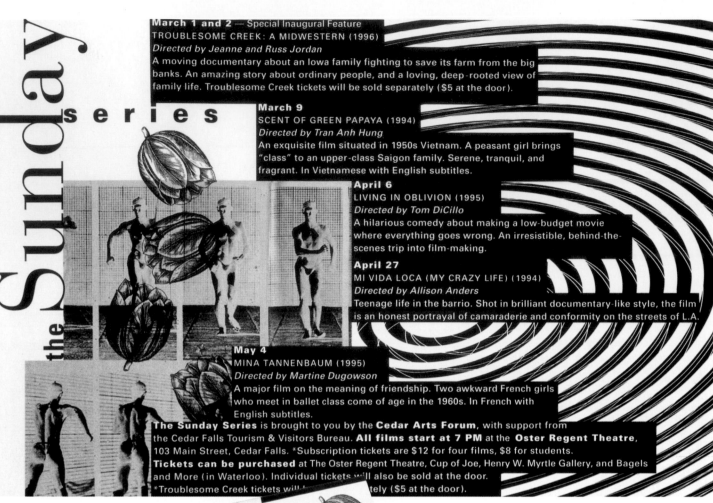

March 1 and 2 — Special Inaugural Feature
TROUBLESOME CREEK: A MIDWESTERN (1996)
Directed by Jeanne and Russ Jordan
A moving documentary about an Iowa family fighting to save its farm from the big banks. An amazing story about ordinary people, and a loving, deep-rooted view of family life. Troublesome Creek tickets will be sold separately ($5 at the door).

March 9
SCENT OF GREEN PAPAYA (1994)
Directed by Tran Anh Hung
An exquisite film situated in 1950s Vietnam. A peasant girl brings "class" to an upper-class Saigon family. Serene, tranquil, and fragrant. In Vietnamese with English subtitles.

April 6
LIVING IN OBLIVION (1995)
Directed by Tom DiCillo
A hilarious comedy about making a low-budget movie where everything goes wrong. An irresistible, behind-the-scenes trip into film-making.

April 27
MI VIDA LOCA (MY CRAZY LIFE) (1994)
Directed by Allison Anders
Teenage life in the barrio. Shot in brilliant documentary-like style, the film is an honest portrayal of camaraderie and conformity on the streets of L.A.

May 4
MINA TANNENBAUM (1995)
Directed by Martine Dugowson
A major film on the meaning of friendship. Two awkward French girls who meet in ballet class come of age in the 1960s. In French with English subtitles.

The Sunday Series is brought to you by the **Cedar Arts Forum**, with support from the Cedar Falls Tourism & Visitors Bureau. **All films start at 7 PM** at the **Oster Regent Theatre**, 103 Main Street, Cedar Falls. *Subscription tickets are $12 for four films, $8 for students.
Tickets can be purchased at The Oster Regent Theatre, Cup of Joe, Henry W. Myrtle Gallery, and Bagels and More (in Waterloo). Individual tickets will also be sold at the door.
*Troublesome Creek tickets will be sold separately ($5 at the door).

THE SUNDAY SERIES

DESIGN FIRM: Philip Fass
LOCATION: Cedar Falls, IA
CLIENT: Cedar Arts Forum
LOCATION: Waterloo, IA
ART DIRECTOR: Phil Fass
DESIGNER: Phil Fass
DISTRIBUTION: 4,000 cards, 600 posters, Regional

Both posters for this film festival were printed in black and seven matching postcards were ganged on the same press sheet. Instead of paying for two press runs, the client was charged only a nominal fee for cutting.

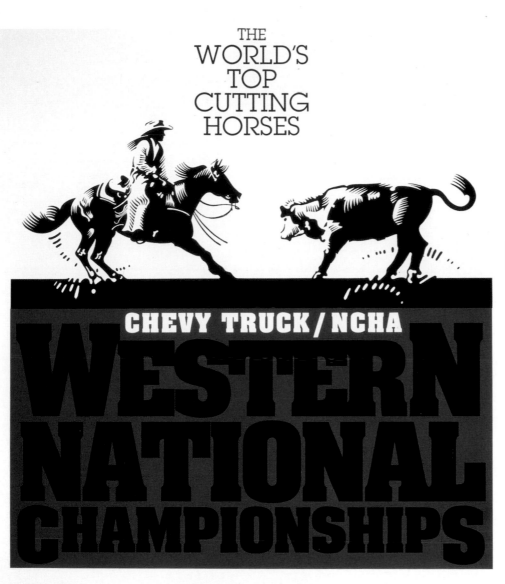

THE
WORLD'S
TOP
CUTTING
HORSES

CHEVY TRUCK / NCHA

WESTERN
NATIONAL
CHAMPIONSHIPS

APRIL 27 TILL MAY 4
GOLDEN SPIKE ARENA
OGDEN, UTAH

CUTTING BEGINS AT 8 AM DAILY. ADMISSION IS FREE EXCEPT FOR THE FINALS.

AN ACTION PACKED SPORT
WESTERN TRADE SHOW DAILY

FOR TICKET INFORMATION
CALL 1-800-44ARENA

WESTERN NATIONAL CHAMPIONSHIP POSTERS

DESIGN FIRM: The Weller Institute for
the Cure of Design
LOCATION: Oakley, UT
CLIENT: National Cutting Horse Association
LOCATION: Fort Worth, TX
ART DIRECTOR: Don Weller
DESIGNER: Don Weller
ILLUSTRATOR: Don Weller
DISTRIBUTION: 2,000 pcs., Local

Sometimes the best solution to the economic problems of producing a design can be found in the design itself. Limited to two colors, the posters created for a rodeo featuring the world's top cutting horses rely mainly on the strength of the type and the illustrations. Both elements emulate an Old West feel without using clip art or public-domain woodcut fonts. Each has the visual strength to convey the message without using elaborate and expensive color schemes or printing processes.

Pro Bono

Besides spreading goodwill where it's needed most, pro bono projects provide studios and agencies with the ideal forum for trying out new design approaches. As the old adage says, "Necessity is the mother of invention." A waived design fee and a low production budget can certainly provide the necessity for a wealth of ingenuity.

Found objects, scanography (placing objects directly onto a flatbed scanner and scanning them in color), hand-assembly of produced pieces, inexpensive specialty printing, and limited color palettes are just a few of the design tools used in solutions for favored charities.

ART PAPERS DISPLAY BOOTH

DESIGN FIRM: Lorenc Design
LOCATION: Atlanta, GA
CLIENT: Art Papers
LOCATION: Atlanta, GA
ART DIRECTOR: Jan Lorenc
DESIGNERS: Jan Lorenc, Xenia Zed,
Ben Apfelbaum
ILLUSTRATOR: Jan Lorenc
PHOTOGRAPHER: Jan Lorenc
DISTRIBUTION: National

Exhibition design is sometimes a necessity for clients who frequent trade shows. Presented at the American Museum Show, the skeleton of this display was made from a wooden teepee form that cost $500. Since the client had a very low budget, the designers went to a rural junkyard and purchased used ladders, wire, utility flags, lights, and an umbrella for next to nothing. Using paint that had been thrown away and specialty art paper samples supplied by the client, the entire assemblage proved that ingenuity and resourcefulness can override the need for additional production expenses.

1996 ANNUAL REPORT

DESIGN FIRM: John Brady Design Consultants
LOCATION: Pittsburgh, PA
CLIENT: Greater Pittsburgh Council/
Boy Scouts of America
LOCATION: Pittsburgh, PA
ART DIRECTOR: John Brady
DESIGNER: Jim Bolander
DISTRIBUTION: 1,500 pcs., Local

The photography costs of this lavish annual report were reduced by using rights-released photography as well as scanography. All pre-press work was completed in-house, thus eliminating the cost of outside prepress services. Wherever possible, the inserts (paper bags, promotional letters, accounting sheets) were supplied in their original form by the client. The collating, binding, rubber-stamping, and finishing were also done in-house at John Brady Design Consultants.

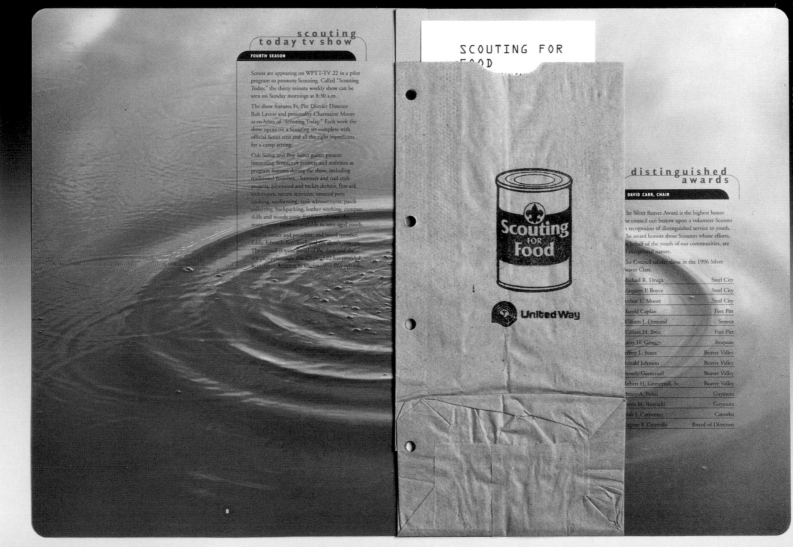

ALL KIDS AT HEART

DESIGN FIRM: Sayles Graphic Design
LOCATION: Des Moines, IA
CLIENT: American Heart Association
LOCATION: Des Moines, IA
ART DIRECTOR: John Sayles
DESIGNER: John Sayles
ILLUSTRATOR: John Sayles
DISTRIBUTION: 500 pcs., Regional

Ingenuity was also at play in this fundraising program. Besides selecting an economical two-color palette for the printed materials and the in-stock box, the designer incorporated a one-color silk-screened tic-tac-toe–style game of wooden blocks into the package. This playful premium replaced the costly thank-you plaque that had traditionally been sent to contributors.

DESIGN FIRM: Mike Salisbury Communications
LOCATION: Torrance, CA
CLIENT: Laguna Art Museum
LOCATION: Laguna Beach, CA
ART DIRECTOR: Mike Salisbury
DESIGNER: Mike Salisbury
ILLUSTRATOR: Brian Sisson
DISTRIBUTION: Local

This pro bono corporate-identity program relies on the interplay of a three-color palette and screens to reduce production costs on the letterhead, cards, envelopes, and other necessary items.

ORANGE
COUNTY

museum
of art

ORANGE COUNTY MUSEUM OF ART

DESIGN FIRM: Mike Salisbury Communications
LOCATION: Torrance, CA
CLIENT: Orange County Museum of Art
LOCATION: Newport Beach, CA
ART DIRECTOR: Mike Salisbury
DESIGNER: Mike Salisbury
ILLUSTRATOR: Bob Malle
DISTRIBUTION: National

This pro bono corporate-identity system focuses its energy on the strength of its overall image, including the logo and type selection. Everything in the program is executed in stark black and white.

ORANGE
COUNTY

museum
of art

NAOMI VINE
Director

850 SAN CLEMENTE DRIVE NEWPORT BEACH CA 92660
p 714 759 1122 fx 714 759 9150

ORANGE
COUNTY

museum
of art

850 SAN CLEMENTE DRIVE NEWPORT BEACH CA 92660 p 714 759 1122 fx 714 759 5623

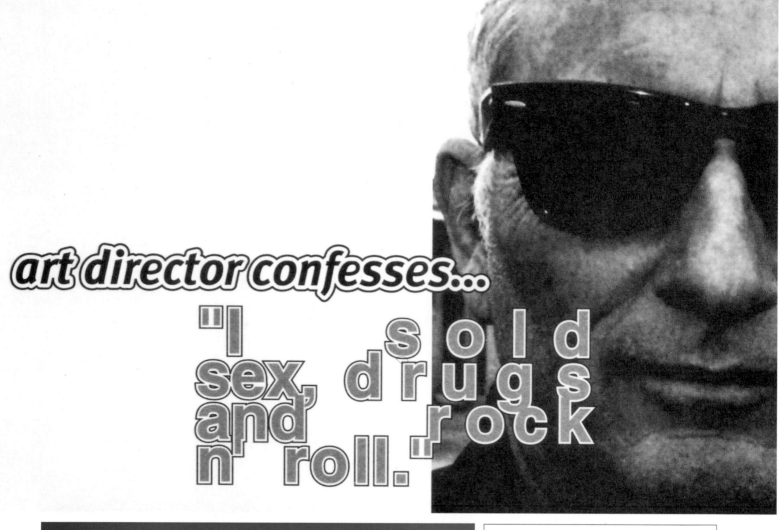

art director confesses...
"I sold sex, drugs and rock n' roll."

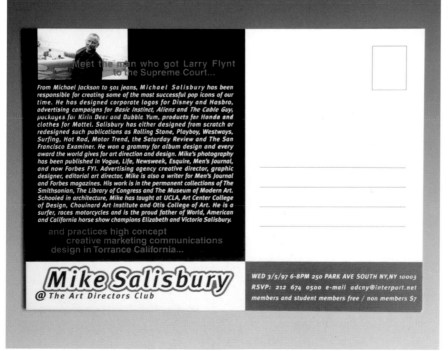

ART DIRECTOR CONFESSES

DESIGN FIRM: Mike Salisbury Communications
LOCATION: Torrance, CA
CLIENT: The Art Directors Club
LOCATION: New York, NY
ART DIRECTOR: Mike Salisbury
DESIGNER: Mary Evelyn McGough
ILLUSTRATOR: Greg McClatchy
DISTRIBUTION: Local

*This pro bono, two-color invitation was created
as a self-mailing postcard to reduce the costs
of both printing and postage.*

DESIGN FIRM: Vaughn/Wedeen Creative
LOCATION: Albuquerque, NM
CLIENT: University of New Mexico Foundation
LOCATION: Albuquerque, NM
ART DIRECTOR: Rick Vaughn
DESIGNER: Rick Vaughn
PHOTOGRAPHERS: Michael O'Shaugnessy,
Michael Barley
DISTRIBUTION: 20 pcs., National

*This pro bono, limited-edition project employed
the use of the studio's in-house inkjet and laser
printers to produce the final pages, which were
assembled and bound by hand.*

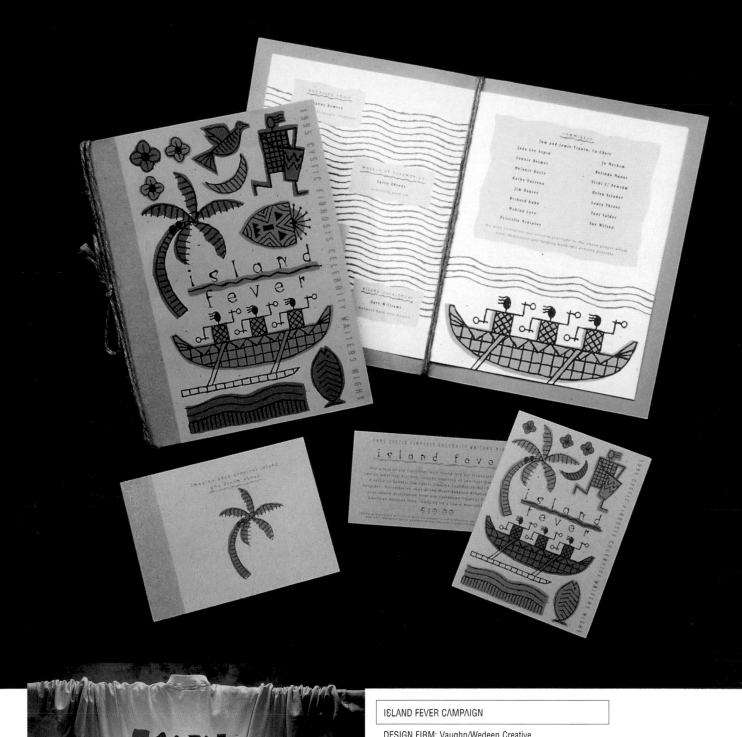

ISLAND FEVER CAMPAIGN

DESIGN FIRM: Vaughn/Wedeen Creative
LOCATION: Albuquerque, NM
CLIENT: New Mexico Cystic Fibrosis Foundation
LOCATION: Albuquerque, NM
ART DIRECTOR: Rick Vaughn
DESIGNER: Rick Vaughn
DISTRIBUTION: 600 pcs., Local/600 pcs., National

This pro bono, limited-edition project employed line art, a three-color palette, color stock, and screens to obtain a rich, effective solution. The same design was also easily translated onto T-shirts, which were printed on in-stock materials.

In the land of Hope there is never any

winter. —a Russian proverb

...the land of Hope

The Chemical team at
Cancer Care, Inc.'s first
Skate for Hope in
Central Park.

land of Hope there is never any

—a Russian proverb

Funding and Support

FOUNDATIONS

The foundation community generously support-
ed Cancer Care's wide range of programs and
services in 1995-96. The Llewellyn Burchell
Foundation, the J.E. and Z.B. Butler Foundation,
the Horace W. Goldsmith Foundation, the
Hagedorn Fund, and the Theodore Luce Fund
were among the many foundations renewing
support for general operating purposes. Others,
such as the Altman Foundation, the Rose M.
Badgeley Residuary Charitable Trust, the Samuel
Eckman Foundation, the Starr Foundation, and
the Marion Esser Kaufmann Foundation funded
specific programs. The New York Community
Trust continued its generous support of Cancer
Care's efforts to assist the City's medically
indigent.

CORPORATIONS

Charitable interest in Cancer Care's programs
and services was demonstrated by corporations
throughout the country. Special efforts such as
Pfizer's underwriting of the Cancer Care Web
site, the Bristol-Myers Squibb Company's
continued support of our toll-free Counseling
Line (1-800-813-HOPE), and funding of our
Melanoma Initiative from the Schering-Plough
Corporation have been instrumental to the suc-
cess of these programs.

SPECIAL FUNDS

Individuals often establish special funds at
Cancer Care in memory or in honor of loved
ones. Special funds provide lasting and invalu-
able support to the agency while keeping these
names in perpetuity. Special funds include the
Lonnie Blutstein Fund, the Bruce Cohen
Memorial Fund, the James P. Erdman Fund,
the Anita Friedman Goldrich-Esther Goldin
Friedman Memorial Fund, the Sylvia Greenspun
Memorial Endowment Fund, the Jack Kemach
Memorial Fund, the Pierre C.Y. Leroy Memorial
Fund, the Jean Miller Memorial Fund, the
Francesca Ronnie Primus Memorial Fund,
the Resnik Family Helping Children Cope Fund,
the Samuel Rosen Memorial Endowment Fund,
the Virginia Saladino Memorial Fund, the Rita
Schwartz Memorial Fund, the Robert Slobodien
Memorial Fund, the Beckie Tesser Memorial
Fund, the Elaine Wrobel Memorial Fund, and
the Helen Zelman Memorial Fund. For further
information, contact the Development Office at
(212) 221-3300, extension 214.

13

CANCER CARE, INC. ANNUAL REPORT
AND BROCHURE

DESIGN FIRM: Lieber Brewster Design
LOCATION: New York, NY
CLIENT: Cancer Care, Inc.
LOCATION: New York, NY
ART DIRECTOR: Anna Lieber
DESIGNER: Anna Lieber
DISTRIBUTION: 4,000 pcs., National

*This agency brochure and annual report
employed existing black-and-white
photography to reduce the costs on
this three-color program.*

Cancer Care, Inc.
1996 Annual Report

A Connection to Hope

Cancer Care, Inc. ®

When you
don't know
where to turn,
Cancer Care
can help.

Providing emotional
support, information,
practical help, and
financial assistance
to people with cancer
and their families for
more than 50 years.

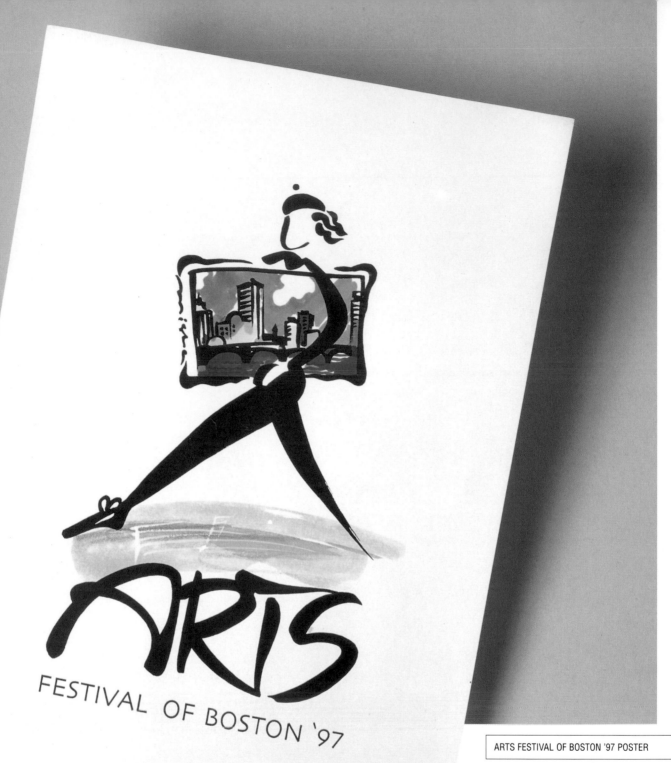

ARTS
FESTIVAL OF BOSTON '97

ARTS FESTIVAL OF BOSTON '97 POSTER

DESIGN FIRM: Misha Design Studio
LOCATION: Boston, MA
CLIENT: Millennium Events Corporation
LOCATION: Boston, MA
ART DIRECTOR: Michael Lenn
DESIGNER: Michael Lenn
ILLUSTRATOR: Michael Lenn
DISTRIBUTION: 100 pcs., Regional

This poster for the Boston Arts Festival was designed as a black-and-white image that could be used in newspaper ads. The designer hand-colored each of the limited-edition, black-and-white posters. Using color markers, he personalized each piece, and the final posters were sold as collectibles to generate extra revenue for the event.

Cancer Care, Inc.
1996 Annual Report

A Connection to Hope

Cancer Care, Inc.®

When you
don't know
where to turn,
Cancer Care
can help.

Providing emotional
support, information,
practical help, and
financial assistance
to people with cancer
and their families for
more than 50 years.

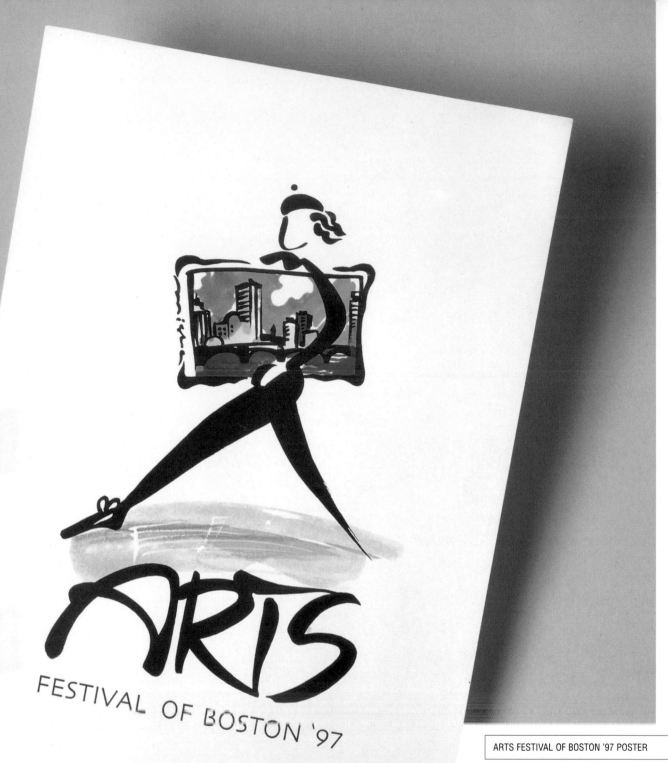

ARTS FESTIVAL OF BOSTON '97

FESTIVAL OF BOSTON '97

ARTS FESTIVAL OF BOSTON '97 POSTER

DESIGN FIRM: Misha Design Studio
LOCATION: Boston, MA
CLIENT: Millennium Events Corporation
LOCATION: Boston, MA
ART DIRECTOR: Michael Lenn
DESIGNER: Michael Lenn
ILLUSTRATOR: Michael Lenn
DISTRIBUTION: 100 pcs., Regional

*This poster for the Boston Arts Festival was
designed as a black-and-white image that
could be used in newspaper ads. The designer
hand-colored each of the limited-edition,
black-and-white posters. Using color markers,
he personalized each piece, and the final
posters were sold as collectibles to generate
extra revenue for the event.*

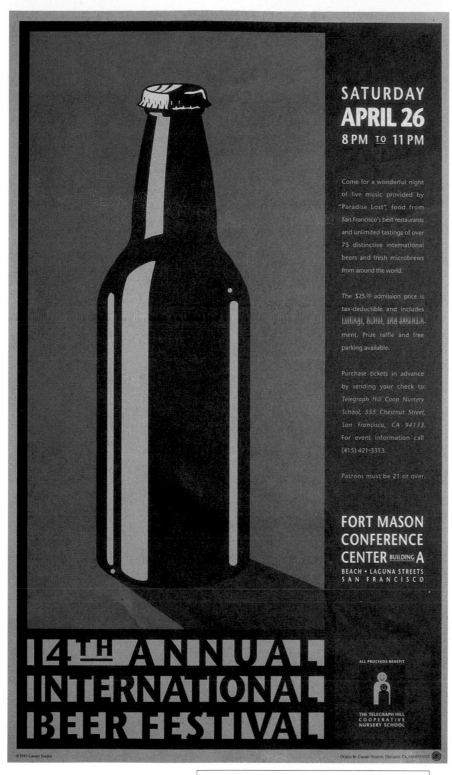

14TH ANNUAL INTERNATIONAL BEER FESTIVAL

DESIGN FIRM: Canary Studios
LOCATION: Oakland, CA
CLIENT: Telegraph Hill Cooperative Nursery School
LOCATION: San Francisco, CA
ART DIRECTORS: Carrie English, Ken Roberts
DESIGNER: Carrie English
DISTRIBUTION: 1,000 posters, 3,000 postcards, Local

By printing the postcards and the posters on the press sheet, the setup and printing costs for this promotion were drastically reduced. The two PMS colors printed on the rich cover stock created high visual impact for a very low cost.

promotion

Another adage, about the shoemaker's children going barefoot, often applies to the budgets designers and even clients allow themselves for self-promotion. But, as in the case of pro bono, ingenuity and necessity seem to walk hand-in-hand these days.

T-shirts need not be designed simply to be given away as promotional items; they can also be sold retail as souvenirs. Labels can be used on envelopes or bottles of homemade wine sent to clients. Spiral-bound sample books can easily be assembled, with bindery techniques limited

only by imagination. These are just a few of the unique solutions designers have recently devised. In every case, the designer has pulled out all the stops (and even a few rubber stamps and tea bags) to create a major impression on a limited budget.

**CHICAGO PICASSO &
CHICAGO WATER TOWER SHIRTS**

DESIGN FIRM: Jim Lange Design
LOCATION: Chicago, IL
CLIENT: Jim Lange Design
LOCATION: Chicago, IL
ART DIRECTOR: Jim Lange
DESIGNER: Jim Lange
ILLUSTRATOR: Jim Lange
DISTRIBUTION: 250 pcs., Local

These self-promotional T-shirts were designed to display the designer's signature style. By using a local theme, he was able to recoup some of his production costs and increase overall exposure by selling a portion at local retail stores that cater to the growing Chicago tourism and convention trade.

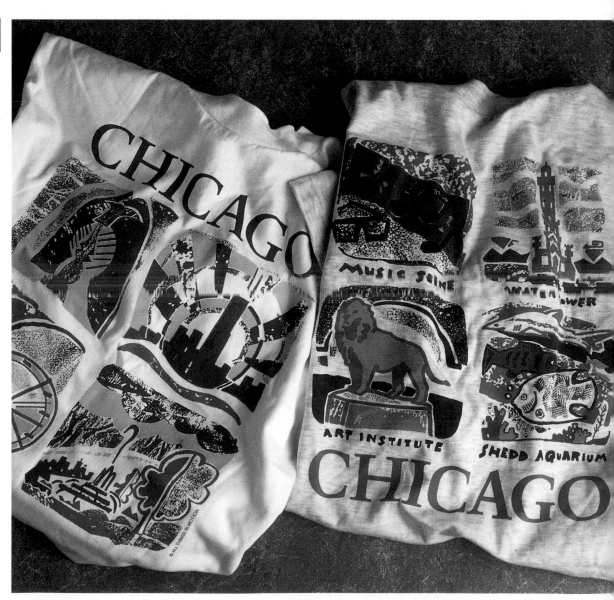

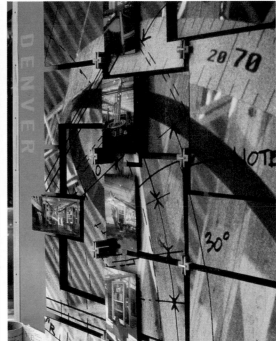

AIA SHOW DISPLAY BOOTH

DESIGN FIRM: Lorenc Design
LOCATION: Atlanta, GA
CLIENT: Lorenc Design
LOCATION: Atlanta, GA
ART DIRECTOR: Jan Lorenc
DESIGNER: Rory Myers
ILLUSTRATORS: Rory Myers, Jan Lorenc
PHOTOGRAPHER: Jan Lorenc
DISTRIBUTION: Regional

A used-plywood stand was covered with foamcore board and color-output prints to create an effective display montage used at an AIA show. The custom attachments were made from available parts. The entire piece cost only $500 in labor and materials.

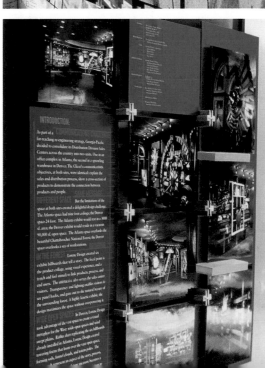

First ask yourself:

What is the worst that can happen?
Then prepare to **accept it**.
Then proceed to **improve** on the worst.

–Dale Carnegie

KARMA CHICKEN

DESIGN FIRM: Moondog Studios, Inc.
LOCATION: Vancouver, BC, Canada
CLIENT: Moondog Studios, Inc.
LOCATION: Vancouver, BC, Canada
ART DIRECTORS: Odette Hidalgo, Derek von Essen
DESIGNERS: Odette Hidalgo, Derek von Essen
DISTRIBUTION: 300 pcs., National

The designers needed a multi-use graphic for their Christmas-season promotion. This two-color sticker was applied to everything from outgoing mail to handmade Christmas cards and bottles of homemade wine that they sent to friends and clients. (According to the designers, good karma was in fact received by all who received this piece.)

JOHN SAYLES LOGO BOOK

DESIGN FIRM: Sayles Graphic Design
LOCATION: Des Moines, IA
CLIENT: Sayles Graphic Design
LOCATION: Des Moines, IA
ART DIRECTOR: John Sayles
DESIGNER: John Sayles
ILLUSTRATOR: John Sayles
DISTRIBUTION: 250 pcs., International

The design studio's promotional piece for its corporate identity work centered around its logos, which were reproduced in one PMS color and wire-o bound. An adhesive gold star on the cover added an unexpected touch.

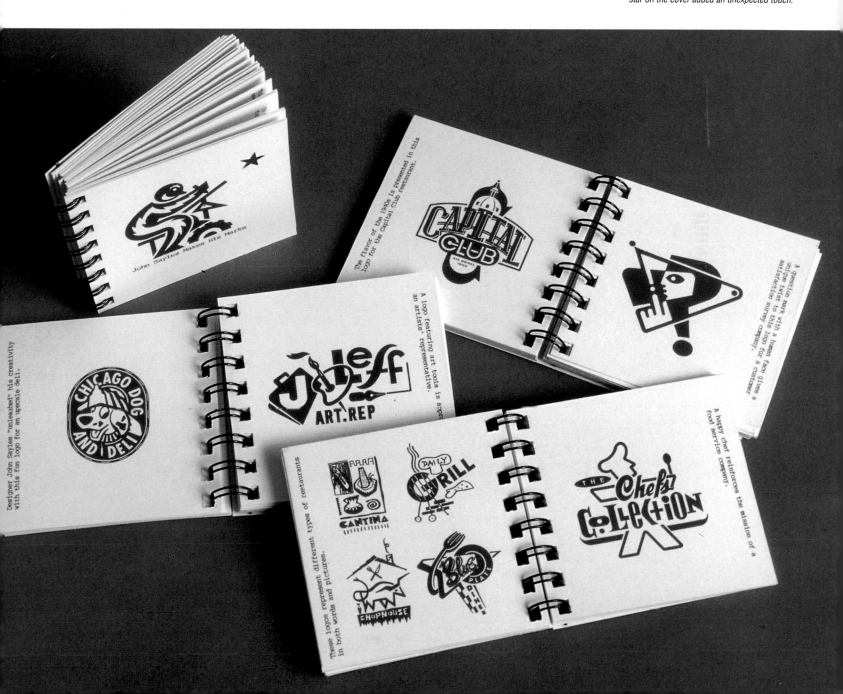

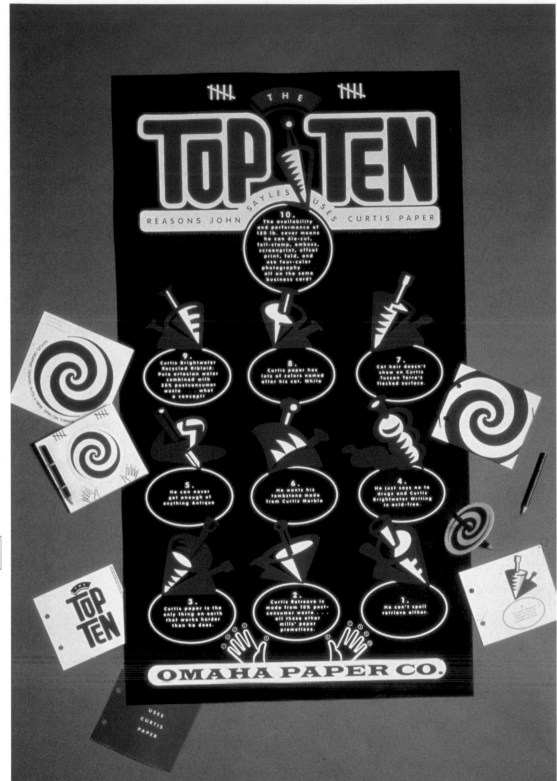

THE TOP TEN REASONS JOHN SAYLES
USES CURTIS PAPERS

DESIGN FIRM: Sayles Graphic Design
LOCATION: Des Moines, IA
CLIENT: Sayles Graphic Design
LOCATION: Des Moines, IA
ART DIRECTOR: John Sayles
DESIGNER: John Sayles
ILLUSTRATOR: John Sayles
DISTRIBUTION: 1,000 pcs., Regional

A paper company provided the cover stock used for this poster and invitation. Since the topic of the presentation was the designer's work for this particular paper company, the exposure value was obvious and greatly reduced the overall production costs. To further the economies, white and red inks were silk-screened onto the poster. The surprise in this package is that the invitation's cover can be assembled into a spinning top.

GIZMO SELF-PROMOTION

DESIGN FIRM: Vaughn/Wedeen Creative
LOCATION: Albuquerque, NM
CLIENT: Vaughn/Wedeen Creative
LOCATION: Albuquerque, NM
ART DIRECTOR: Rick Vaughn
DESIGNER: Rick Vaughn
PHOTOGRAPHER: Michael Barley
DISTRIBUTION: 300 pcs., National

*Inexpensive trinkets, stock cans, and inkjet-
printed labels were all assembled in-house
to create this lively self-promotion piece.*

Promotion **139**

we have what it takes to start something **big.**

We're blurring the line between design studio and full-service ad agency.

To refer to us as a design studio would barely scratch the surface.

We pour over all facets of promotion, offering a tasty blend of strong visuals, smooth words, and refreshing concepts with a twist.

We're set up to serve all your marketing needs—we can even get you an ID.

Canary Studios. Stirring concepts.

Our capabilities go much deeper than that. We offer design and marketing solutions that break through and leave a lasting impression. Canary Studios. Sharp Visuals.

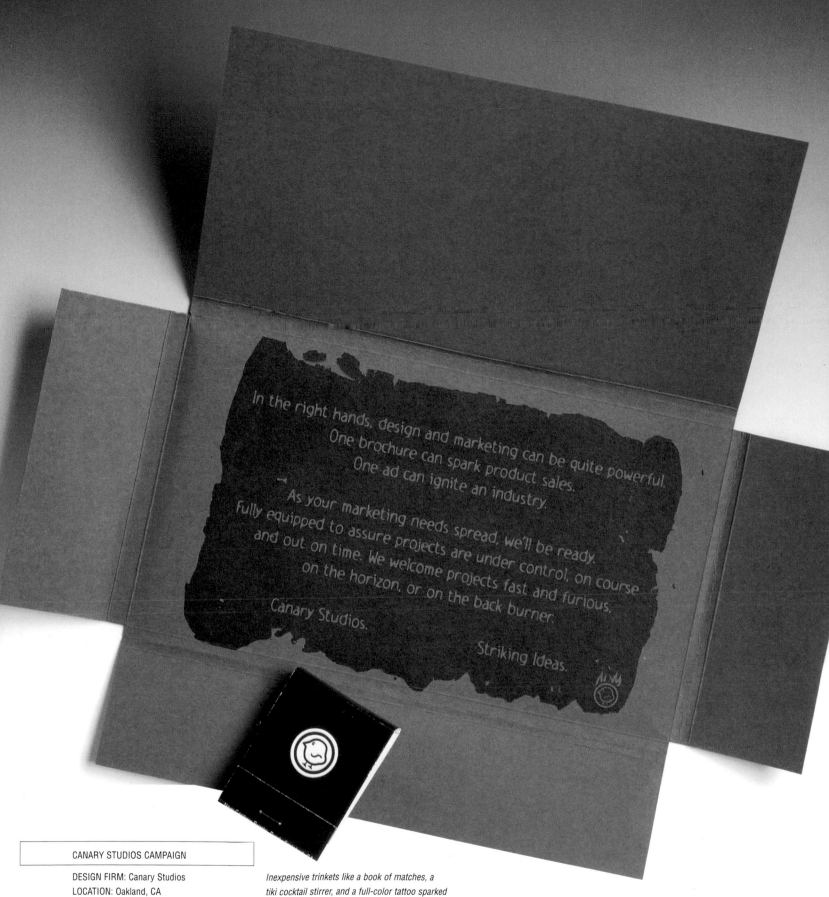

In the right hands, design and marketing can be quite powerful.
One brochure can spark product sales.
One ad can ignite an industry.

As your marketing needs spread, we'll be ready,
fully equipped to assure projects are under control, on course
and out on time. We welcome projects fast and furious,
on the horizon, or on the back burner.

Canary Studios.

Striking Ideas.

CANARY STUDIOS CAMPAIGN

DESIGN FIRM: Canary Studios
LOCATION: Oakland, CA
CLIENT: Canary Studios
LOCATION: Oakland, CA
ART DIRECTORS: Carrie English, Ken Roberts
DESIGNERS: Ken Roberts, Carrie English
ILLUSTRATOR: Carrie English
DISTRIBUTION: 2,000 pcs., Local

*Inexpensive trinkets like a book of matches, a
tiki cocktail stirrer, and a full-color tattoo sparked
curiosity as each item rattled in the one-color
stock boxes that were created with a simple die
cut. The finished boxes were self-mailing and
only needed to be folded and sealed to ship.*

DESIGN FIRM: Vaughn/Wedeen Creative
LOCATION: Albuquerque, NM
CLIENT: Vaughn/Wedeen Creative and Balboa Travel
LOCATION: Albuquerque, NM
ART DIRECTOR: Rick Vaughn
DESIGNER: Rick Vaughn
DISTRIBUTION: 25 pcs., International

*All the pieces for this self-promotion campaign were
printed on the studio's in-house inkjet printer and
finished with a spiral binder and rubber stamps.*

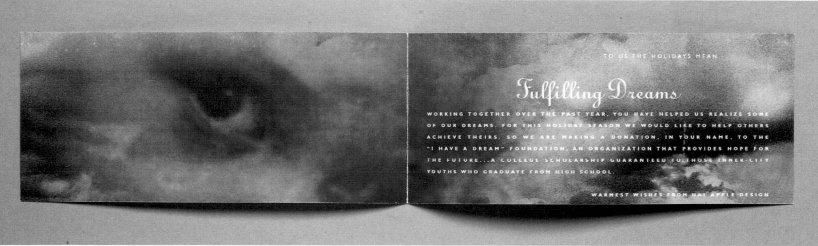

WHAT DO THE HOLIDAYS MEAN TO YOU?

DESIGN FIRM: Halapple Design & Communications, Inc.
LOCATION: Manhattan Beach, CA
CLIENT: Halapple Design & Communications, Inc.
LOCATION: Manhattan Beach, CA
ART DIRECTOR: Hal Apple
DESIGNER: Andrea Del Guerico
PHOTOGRAPHER: Jason Hashmi
DISTRIBUTION: 100 pcs., National

The studio's Christmas present was a donation in the recipient's name to the I Have a Dream Foundation. To economically produce this full-color holiday greeting, the studio shot its own photography and printed the two-sided, folded cards in-house on a Canon Fiery printer on Canon Fiery paper.

THE *APPLE* REMEDY

At Hal Apple Design we believe a tranquil mind and a moment of quiet reflection can go a long way to help uncover creative solutions. Sample our special blend of apples, herbs and spices. As you sip this fragrant tea, imagine your communications program, designed with a purpose and ready when needed.

Consider Hal Apple Design.

Enjoy your tea. We'll call you in the morning.

310.318.3823
1111 Ocean Drive Suite 101, Manhattan Beach, CA 90266

HALAPPLE TEA BAG

DESIGN FIRM: Halapple Design & Communications, Inc.
LOCATION: Manhattan Beach, CA
CLIENT: Halapple Design & Communications, Inc.
LOCATION: Manhattan Beach, CA
ART DIRECTOR: Hal Apple
DESIGNERS: Alan Otto, Jason Hashmi
DISTRIBUTION: 1,000 pcs., National

Using the strongest association with the studio's name, the theme of apples was employed to tie together a new identity program. The initial contact is made with a one-color promotional piece printed on colored paper stock that contains an imaginatively packaged apple-cinnamon tea bag. The complete package was assembled at the studio as needed.

HALAPPLE BUSINESS CARD AND LETTERHEAD

DESIGN FIRM: Halapple Design & Communications, Inc.
LOCATION: Manhattan Beach, CA
CLIENT: Halapple Design & Communications, Inc.
LOCATION: Manhattan Beach, CA
ART DIRECTOR: Hal Apple
DESIGNERS: Alan Otto, Jason Hasmi,
Andrea Del Geurico, Hal Apple
DISTRIBUTION: 5,000 pcs., International

*Many times, a business card is a design studio's best
form of self-promotion, especially if it reflects a balance
between economical print costs and a striking design
solution. The card uses a duplex paper stock of French
Dur-O-Tone cover stock in Primer Rust and Speckletone
Oatmeal printed in one color. The savings allowed the
punching of a special die cut on the letterhead and
business card, which was itself recycled from a previous
stationery design.*

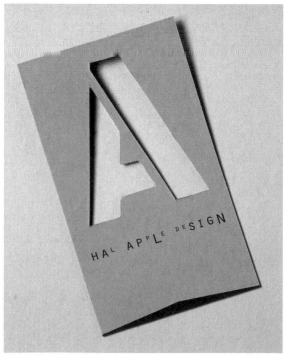

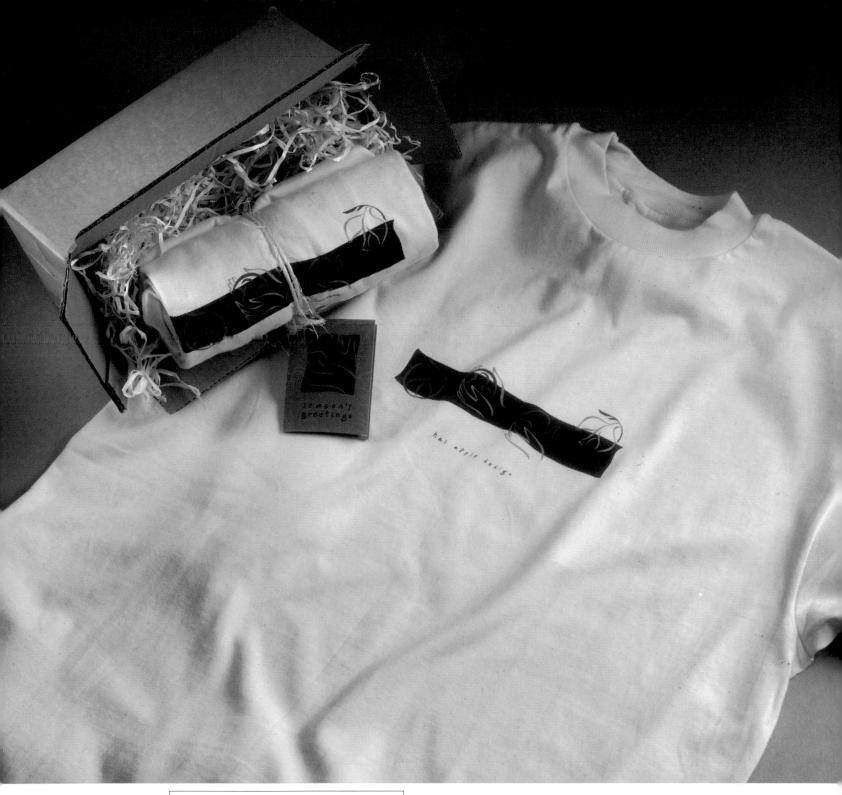

HALAPPLE T-SHIRT

DESIGN FIRM: Halapple Design & Communications, Inc.
LOCATION: Manhattan Beach, CA
CLIENT: Halapple Design & Communications, Inc.
LOCATION: Manhattan Beach, CA
ART DIRECTOR: Hal Apple
DESIGNERS: Michael Rowley, Hal Apple, Jill Ruby
DISTRIBUTION: 1,000 pcs., National

*This self-promotion piece relied on in-stock items.
An in-stock corrugated box filled with excelsior holds
a three-color, custom-printed in-stock T-shirt that was
wrapped with sisal cord and a small tag. The entire
package was assembled at the studio.*

HALAPPLE HOLIDAY PACK

DESIGN FIRM: Halapple Design & Communications, Inc.
LOCATION: Manhattan Beach, CA
CLIENT: Halapple Design & Communications, Inc.
LOCATION: Manhattan Beach, CA
ART DIRECTOR: Hal Apple
DESIGNERS: Alan Otto, Jason Hashmi, Hal Apple,
Rebecca Cwiak, Andrea Del Geurico
DISTRIBUTION: 500 pcs., National

*Clip art and one-color printing on a colored Cross Pointe
Passport Gypsum cover stock greatly reduced the
production cost of this holiday promotion, which was
collated and assembled in-house and bound with a
piece of colored raffia. Each piece was mailed in an
off-the-shelf specialty paper envelope.*

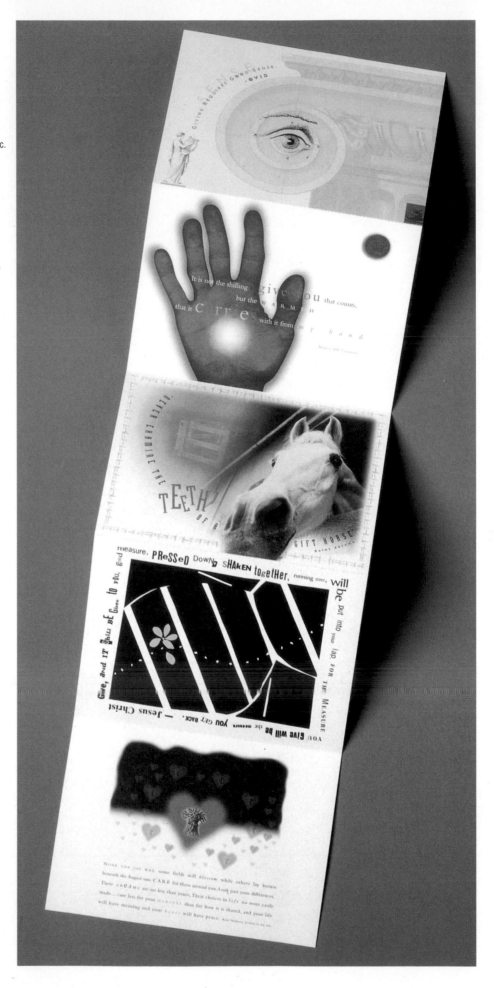

If it is truly better
to **give** than to receive,
the **best** gift would be *one*
that could *be given* to others.

That thought
inspired
the enclosed **gift** from

HAL APPLE DESIGN

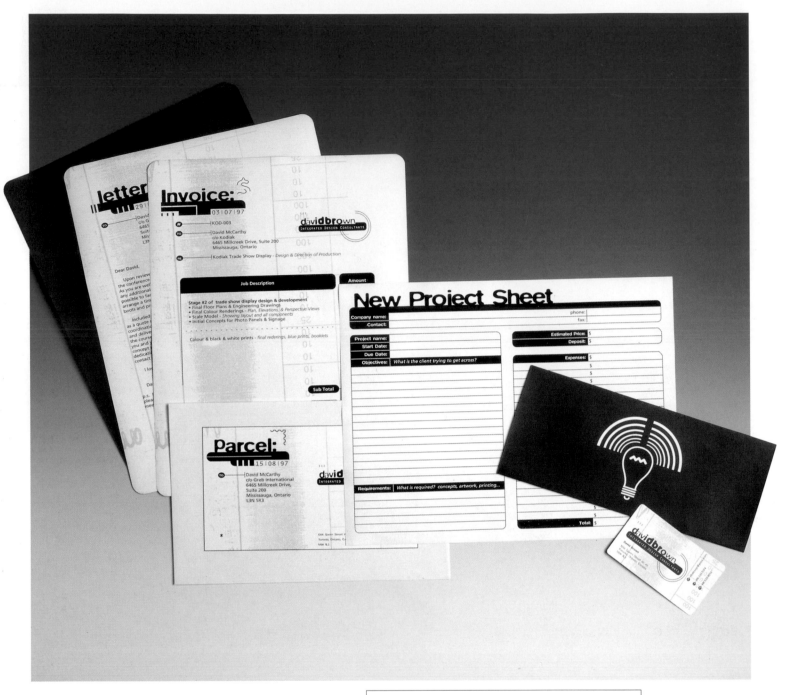

DESIGN FIRM: David Brown Integrated Design Consultants
LOCATION: Toronto, ONT, Canada
CLIENT: David Brown Integrated Design Consultants
LOCATION: Toronto, ONT, Canada
ART DIRECTOR: David Brown
DESIGNER: David Brown
DISTRIBUTION: 1,000 pcs., National

This identity program relies almost entirely on technology. The one-color business cards used a simple in-stock die to create the rounded corners. The remaining letterhead, brochure, and business forms are printed on a 600-dpi laser printer as needed on pre-printed one-color shells bearing the company's logo.

MIRES DESIGN CASE-STUDY BOOK:
PENNY HARDAWAY LOGO

DESIGN FIRM: Mires Design
LOCATION: San Diego, CA
CLIENT: Mires Design
LOCATION: San Diego, CA
ART DIRECTOR: José A. Serrano
DESIGNERS: José A. Serrano, Jeff Samaripa
DISTRIBUTION: 100 pcs., National

Used as a very effective marketing tool to present how the studio's design process works, this case-study book offers a step-by-step presentation of the thumbnails, notes, and concepts that developed during the entire project. Each page is photocopied in black-and-white except for the finished logo, which is color copied. The compiled sheets are velo-bound and heat-sealed into a three-part hardcover case. All printing and assembly is executed in-house, except for the printed panel that appears on the front cover; it was produced as a fill-in-the-blank shell.

CONSIDER

DESIGN FIRM: Stewart Monderer Design, Inc.
LOCATION: Boston, MA
CLIENT: Stewart Monderer Design, Inc.
LOCATION: Boston, MA
ART DIRECTOR: Stewart Monderer
DESIGNER: Aime Lecusay
PHOTOGAPHER: Keller & Keller
DISTRIBUTION: 1,500 pcs., Local

A five-panel square format was selected as the vehicle for a series of thought-provoking words and photographs printed in three PMS colors. The only bindery work required was folding. Back at the studio, the card was packaged together with a laser-printed vellum slipsheet. The entire promotion was assembled at the studio with a hand-folded and hand-glued belly band that was rubber-stamped with silver ink.

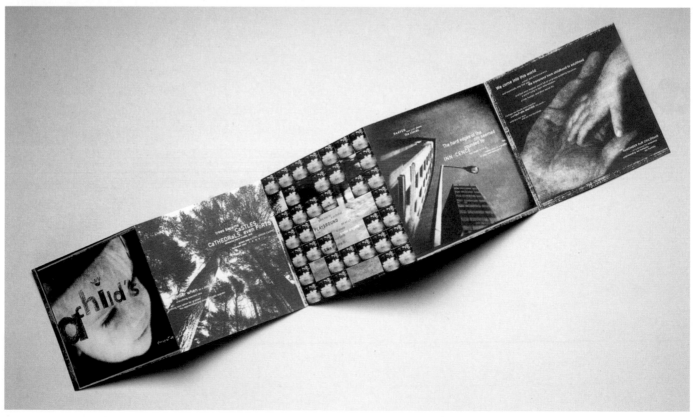

Now available whenever you log on: Mires Design.

We've been doing it since 1983. (Some say we've gotten pretty good.)

www.miresdesign.com

Scott Mires, to be exact. He's the founder of our company. If you like what you see, e-mail him from our online portfolio. Or simply call: 619-234-6631.

As in communications, created to build brands, drive sales and, yes, even promote the occasional web site.

MIRES DESIGN WEB POSTCARD

DESIGN FIRM: Mires Design
LOCATION: San Diego, CA
CLIENT: Mires Design
LOCATION: San Diego, CA
ART DIRECTOR: John Ball
DESIGNERS: John Ball, Gale Spitzley
DISTRIBUTION: 1,500 pcs., National

This clean and simple two-color, large-format postcard was designed to direct more Internet traffic to the studio's Website. Self-mailing and visually striking, this promotion cost less than a brochure, poster, or conventional sales letter to produce and distribute.

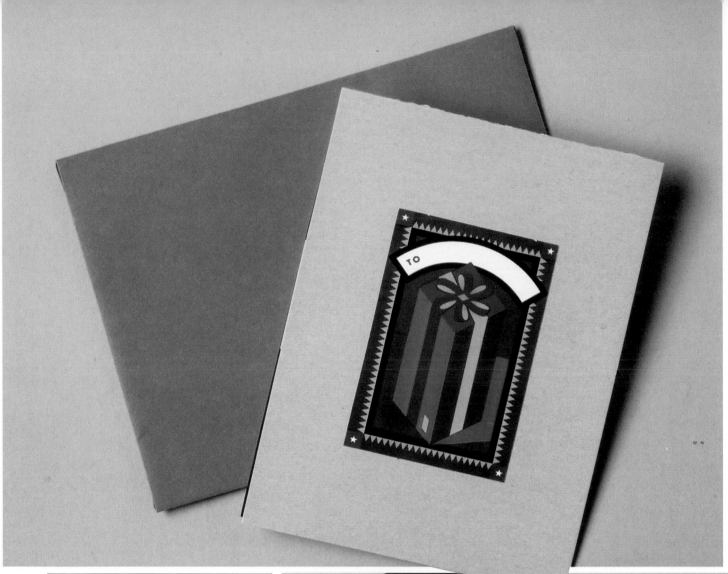

MAY THE SPIRIT OF THE SEASON STICK WITH YOU ALL YEAR LONG

DESIGN FIRM: Lambert Design
LOCATION: Dallas, TX
CLIENT: Lambert Design
LOCATION: Dallas, TX
ART DIRECTOR: Christie Lambert
DESIGNER: Joy Cathy Price
DISTRIBUTION: 100 pcs., Regional

This imaginative holiday promotion was created and assembled in-house. The nine labels used in the package were printed on an Indigo printer on self-adhesive label paper and cut on a paper cutter. The duplex card stock was cut and folded by hand. The band used to secure the labels to the card was cut and glued to the card by hand as well.

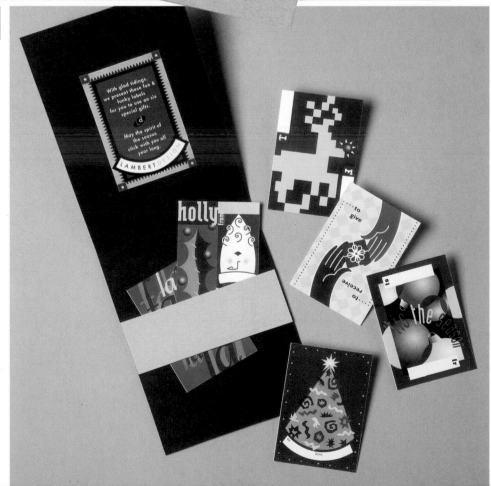

GLOWING

expertise

ON
THE
SHIMMERING
PATH
OF A
SHOOTING

star

ON THE SHIMMERING PATH OF A SHOOTING STAR

DESIGN FIRM: Grafik Communications, Ltd.
LOCATION: Alexandria, VA
CLIENT: Becker Group
LOCATION: Baltimore, MD
DESIGNERS: Gretchen East, Judy Kirpich
DISTRIBUTION: 2,000 pcs., National

The cover and back stand of this piece were printed on Wassau Celebration stock in four-over-one color to keep the costs down. The four-color interior was printed on calendar sheets and the final binding was done in wire-o.

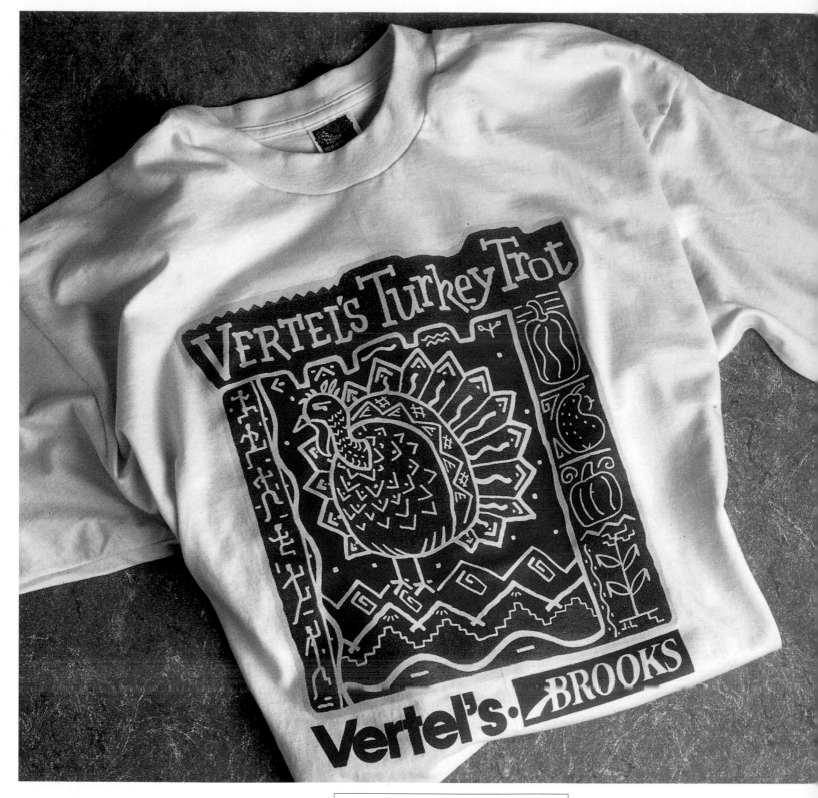

TURKEY TROT RACE PARTICIPANT SHIRT

DESIGN FIRM: Jim Lange Design
LOCATION: Chicago, IL
CLIENT: Capri, Inc.
LOCATION: Chicago, IL
ART DIRECTOR: Jan Caille
DESIGNER: Jim Lange
ILLUSTRATOR: Jim Lange
DISTRIBUTION: 1,500 pcs., Local

The production costs for this promotional T-shirt were defrayed by incorporating the two sponsors' logos into the image. Each company purchased additional shirts for use in its own promotions, providing an added value to the overall project.